American Primitive Painting

JEAN LIPMAN

DOVER PUBLICATIONS, INC.,

NEW YORK

Published in Canada by General Publishing
Company, Ltd., 30 Lesmill Road, Don Mills,
Toronto, Ontario.
Published in the United Kingdom by Constable
and Company, Ltd., 10 Orange Street, London WC 2.

This Dover edition, first published in 1972, is an
unabridged republication of the work originally
published by Oxford University Press, New York,
in 1942. The present edition has a different selection
of color plates.

International Standard Book Number: 0-486-22815-0
Library of Congress Catalog Card Number: 79-184124

Manufactured in the United States of America
Dover Publications, Inc.
180 Varick Street
New York, N. Y. 10014

DEDICATED

TO THE MEMORY OF

FREDERIC FAIRCHILD SHERMAN

Acknowledgments

My greatest indebtedness is to my husband, Howard Lipman, who has acted as consultant and critic at every stage in the writing of this book.

I wish to thank the magazines *Antiques* and *Art in America* for permission to reprint portions of my articles on American Primitive Painting published by them; Mrs. F. F. Sherman for permission to publish the material from Lucy McFarland Sherman's painting portfolio; and the *Scientific American* for allowing me to quote the text and reproduce the wood-cuts from Rufus Porter's early articles on wall painting.

Also the Frick Art Reference Library and the Downtown Gallery, for having made available a number of the photographs here reproduced; William R. Scott, Inc., for the photographs for plates 94 and 95, first reproduced in Janet Waring's *Early American Stencils;* and all the museums and individual collectors who have provided me with photographs of their Primitives.

I want especially to acknowledge the generous co-operation of Mr. Holger Cahill, Mr. Harry Stone, Mr. J. S. Halladay, and Mr. H. G. Thomas, who read my manuscript before publication, made many useful suggestions, and added much valuable data to the last chapter.

Contents

Plates

Color plates appear after page 16.

SOME COMPARISONS
(Pages 11-16)

PORTRAITS—FAMILY GROUPS—MINIATURE PORTRAITS
(Pages 23-54)

LANDSCAPE—GENRE—BIBLICAL AND HISTORICAL SCENES—
SHIP PICTURES
(Pages 59-96)

LADIES' WORK: DECORATIVE PIECES—MEMORIALS— PORTRAITS—SCENES
(Pages 103-120)

WALL DECORATIONS: FRESCOES AND PAINTED PANELS
(Pages 127-137)

AMERICAN PRIMITIVE PAINTING

A Critical Definition

THE American Primitive, not long ago ignored by critics of American painting, is now suffering from the undiscriminating enthusiasm of discovery and crusade. Numerous exhibitions and articles have popularized the American Primitive, but the qualities that constitute a 'Primitive' are still nebulous in the mind of the public. The American Primitive has not yet been defined in terms of its special period or its intrinsic style, the adjective 'primitive' being loosely applied to describe any sort of early, provincial, crude, or anonymous American painting.

The paintings to be here considered are all 'primitive' in a sense directly opposed to 'academic,' in style abstract as opposed to illusionistic. They spring from craft rather than painters' traditions, and so are not related to any schools of painting; are typically non-derivative, individual, unpretentious, most often anonymous. This type of painting flourished in the first three quarters of the nineteenth century. Despite the general misconception that the quality of a Primitive is in direct proportion to its early date, the height of achievement in primitive painting was actually reached toward the middle of the nineteenth century. At this time the itinerant limners had developed a unique style of portraiture, the female seminaries were turning out accomplished watercolorists, and numbers of artists were painting highly original scenes and decorating the walls of houses with remarkable frescoed landscapes. Hundreds of portraits, landscapes, genre scenes, ship pictures, memorials, and still-life paintings bear witness to the popularity—and the quality—of this

(3)

unique nineteenth-century American art. Pennsylvania fractur work, which descends directly from German sources, does not belong in this book, nor do our earliest portraits by artists such as Smibert, Feke, Blackburn, Theus, Badger, Hesselius, Dummer, the Duyckinks, or Pieter Vanderlyn, all of whom derive from European traditions. Provincial painters such as Richard Jennys and Ralph Earl represent a transitional group—certainly not of the Stuart-Copley-West tradition and still not quite primitive in approach. It was not till the very end of the eighteenth century that the purely native, unacademic American art, which we will term 'primitive,' sprang into being and—this is an important point—it did so quite spontaneously. Certainly the primitive painters who created the body of work illustrated in this book did not derive from the work of our seventeenth- and eighteenth-century portraitists, nor did they lay any foundation for our contemporary 'self-taught' painters; and any attempt to trace a consecutive development through the centuries for American primitives would necessarily distort their history.

The term primitive is possibly open to criticism as applied to nineteenth-century American painting. But it does describe the type of vision and the style of the homogeneous group of remarkable native American paintings, dating with few exceptions from about 1790 to 1875, which this book will present as an important chapter in the history of American painting.

A remarkable small book written a generation ago to define the non-visual quality of archaic Greek art—*The Rendering of Nature in Early Greek Art,* by Emanuel Löwy—might interest us today in connection with American Primitive painting. This book enumerates the chief characteristics of archaic style and concludes that 'in all these characteristics there is one common principle, namely, an independence of the real appearance of objects, an independence that not seldom amounts to open opposition.' This is also the principle, the stylistic personality, of the American Primitive. Löwy explains this type of art not as a deliberate convention or as the consequence of a dislike of optical illusion, but as a result of what he terms 'the primitive memory image.' The memory, he explains, does not retain all images equally, but makes a selection of those aspects which present the

object in the greatest clearness and completeness. Thus, he goes on to explain, 'along with the pictures that reality presents to the eye, there exists another world of images, living or coming into life in our minds alone, which, though indeed suggested by reality, are nevertheless essentially metamorphosed. Every primitive artist, when endeavoring to imitate Nature, seeks with the spontaneity of a psychical function to reproduce merely these mental images.' Extreme fidelity to the mental picture therefore involves extreme perversion of reality. This is why primitive or archaic arts are invariably distinguished by a unique freedom from realism which has as a result the free, unself-conscious ability to develop the purely aesthetic qualities of abstract design. It is this abstraction which has recently placed a premium upon primitive art. It seems worth noting here that such outstanding modern artists as Robert Laurent, William Zorach, Stephan Hirsh, Alexander Brook, Elie Nadelman, and Charles Sheeler were among the first to recognize the quality of the American Primitives and have gained inspiration from collecting them. Our generation values abstract quality above all else. Within the last thirty years, painters and sculptors created for the first time in history a deliberately abstract art, and art historians and collectors have set a higher value upon the abstract attributes of traditional art than has ever been done before. Thus Egyptian art, archaic Greek art, early Italian painting, African wood sculpture, and now American Primitives are accorded a place in art history along with the Parthenon sculptures, Raphael, Delacroix, and Gilbert Stuart.

That there can be a change or a difference of opinion concerning the value of abstractness is currently ignored. However, archaic Greek art and Italian as well as American Primitives did not always enjoy their present repute. They were formerly described as crude, uncouth, stiff, distorted, poorly executed, by critics whose touchstone of value was fidelity to real, or visual, appearance. That the same objects are now described as original, individual, formalized, lucid, abstract merely implies a shift in the attitude of the critic, who has come to value abstract above illusionistic representation and to evaluate primitive art positively rather than negatively.

(5)

Needless to point out, there are broad underlying conditions accountable for the production, at any given time and place, of one type of art form rather than another. The late eighteenth and especially the first three quarters of the nineteenth century was the great period for primitive painting in America. In the seventeenth and early eighteenth century, life was too difficult to allow masses of people to become urgently concerned with the arts; art was for wealthy individuals, and the artists employed by them were professional painters trained in the English or Dutch traditions. And after the eighteen-sixties the photographer began to supersede the limner, while chromos and Currier and Ives prints became cheap-and-easy substitutes for the painted landscapes and decorative pieces. Primitive painting, coming out of the eighteenth-century craft tradition, flourished chiefly in New England and Pennsylvania, the chief craft centers of America, though numerous examples have been found in New York and New Jersey and in the southern and middle western states. The group of 'primitive' or 'folk' painters consisted of ordinary craftsmen, sign, coach, and house painters, who turned to painting for pleasure and profit; housewives who occupied leisure hours by making tinsel and watercolor pictures; and young ladies whose seminary curriculum included drawing on sandpaper, working in watercolors, and learning the use of vegetable dyes for painting on velvet, along with reading, writing, dancing, and sewing. Last but not least there were the itinerant limners and house decorators, who, without any special training to recommend them, travelled from town to town painting likenesses of the townspeople and decorating the walls of their houses with stencilled designs or free-hand landscapes.

Most of these painters remain anonymous. All of them were untrained. This means that they lacked the academic training which aimed at developing a capacity for approximating, in paint, the visible appearance of things. The untutored painter attempted to reproduce reality, but his relative inability to do so because of the simplicity of his vision and the limitations of his technique resulted in an essentially abstract style. His technical liabilities made way for a compensating emphasis on pure design.

(6)

In every type of representation the distinguishing aesthetic qualities of the American Primitive depend directly upon non-realistic factors. The portraits were rarely painted strictly from life. The primitive artist typically allowed himself free rein in depicting pose, gesture, even details of costume, accessories, and background. In some cases, in fact, the bodies were prepared during the winter months and in the spring the itinerant limner set out with his stock of canvases to hunt for customers. As he had no specific model for his bodies, such a limner was apt thoroughly to indulge his liking for a decorative silhouette, for the linear rhythm of ribbons and laces, or for the sweeping lines of a waistcoat. In the landscapes, the attempt to create an effect of perspective often achieved instead an almost cubistic organization of form. It is significant to note that in many of the frescoed landscapes the artist did not hesitate to paint houses and fences with the help of stencils, and that compasses as well as stencils were commonly used in the construction of landscapes painted on velvet. In the velvet and watercolor still-life paintings, stencils were generally used to construct the picture, and in the 'fancy pieces' and 'mourning pictures' there is a frank absence of any realistic model.

The non-optical approach explains not only the departures from visible reality in the primitive pictures, but also the so-called inconsistencies—considered from the point of view of visual plausibility—sure to exist between various aspects of a picture. In scenes representing religious, historical, or literary subjects it was not considered undesirable to include incidents which could not have been juxtaposed in actual existence. As the primitive limner did not conceive his portrait as an optically consistent whole, he did not consider it objectionable to attach a relatively realistic head to a decoratively planned torso. A landscape painter saw nothing amiss with placing in his sky a geometrically rayed sun and a scattering of stencilled stars and then including cast shadows in his representations of trees and houses. In Eunice Pinney's watercolor portrait of two women (Plate 85) one may see how the cast shadows have been carefully painted around instead of over the unbroken geometric design of the carpet.

The style of the typical American Primitive is at every point based upon an

essentially non-optical vision. It is a style depending upon what the artist knew rather than upon what he saw, and so the facts of physical reality were largely sifted through the mind and personality of the painter. The degree of excellence in one of these primitive paintings depends upon the clarity, energy, and coherence of the artist's mental picture rather than upon the beauty or interest actually inherent in the subject matter, and upon the artist's instinctive sense of color and design when transposing his mental pictures onto a painted surface rather than upon a technical facility for reconstructing in paint his observations of nature.

Abstract design is the heart and soul of the American Primitive, and it is this fact which has won for it the acclaim of the moderns. The compositional means used by the artist to set down clearly and forcibly the mental pictures upon which he based his representation resulted, unconsciously, in an enhancement of abstract design at the expense of illusionistic realism. Individual objects were most often represented in profile or in full face, form was abbreviated and flattened, movement was restricted, contour lines were emphasized, and colors were sharpened. All the compositional aspects of a primitive picture reveal a non-optical attitude. Each unit of the painting seems to exist separately, as it did in the series of memory images in the artist's mind, and these images appear to have been combined rather than synthesized in the final representation.

The essential character of the primitive painter's vision and method may be most clearly seen by comparing a few academic or illusionistic paintings with primitive versions of similar subjects. The following plates need little comment. Compare, for instance, *Washington's Tomb and Mount Vernon* by the academic painter W. H. Bartlett (Fig. 6) with the anonymous memorial for Polly Botsford (Fig. 5). In the academic picture there is an optical unification of the whole scene. The eye of the spectator takes in the pictured area as a whole just as the artist's eye originally observed the scene which he chose to represent. In the primitive picture there is no unifying aerial perspective, no naturalistic lighting, no approximation of the appearance of observed reality. The spectator's eye travels from one portion of the picture to another, accumulating bit by bit the represented content,

(8)

for it was in this way that the primitive artist constructed his picture. In the academic picture the people, the buildings, the water and foliage are naturalistically rendered. In the primitive watercolor each of these is rigorously simplified and cast into a stylized form. The foliage has the quality of decorative embroidery, the mother and two children at the right are three crisp triangles, and the skeleton church is a geometric abstraction rather than a representation of a real building.

The basic characteristic of the American Primitive is abstractness, an inevitable and unconscious result of the non-visual attitude of the artist. The quality of the primitive paintings does not vary with the degree of primitiveness, but with the mental vigor and creative power of the artist. Without this creative energy the primitive picture is merely crude. There is much plain bad painting among so-called primitives, and it is important to distinguish crudity or childlike naïveté from the rich abstract design which characterizes the primitive masterpieces.

It does seem, however, that the creative power of the gifted artist is preserved in its fullest flavor in the more primitive paintings. It is certain that the imposed standards of an academic training raised to the level of passable performance a great many mediocre artists, but it seems possible that an academic education tended to dilute the originality and to standardize the work of some extraordinarily gifted individuals.

In an attempt to estimate the gains and losses to our robust and talented early American painters resulting from their acquisition of an academic point of view and technical skill, it is interesting to contrast the very early untutored works of our leading painters with their mature product. This contrast parallels in a revealing manner the comparison between primitive and academic painting. For example let us compare with his mature work Benjamin West's little landscapes in the Pennsylvania Hospital painted at the age of fourteen. A number of such comparisons should lead to a definite idea of exactly what was gained and what lost in the formal training of our early American painters, and on that basis to a strengthening of old convictions or, perhaps, a radical revaluation. In the opinion of this writer the early, relatively primitive work of our greatest painters com-

pares favorably with their more sophisticated later work. And radical though this may seem, it is the author's firm belief that a small number of highly gifted primitive painters, unhampered by any external requirements or restrictions, arrived at a power and originality and beauty which was not surpassed by the greatest of the academic American painters.

SOME COMPARISONS

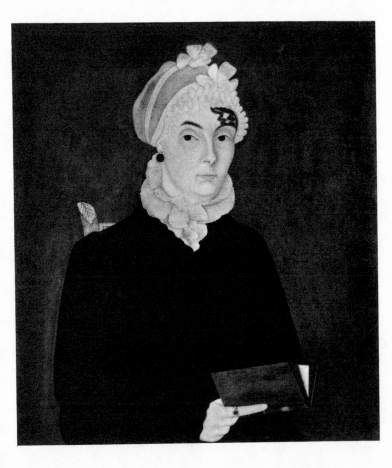

1. 'LADY OF HORNELL'
 Oil on canvas c.1810
 Detroit Institute of Art

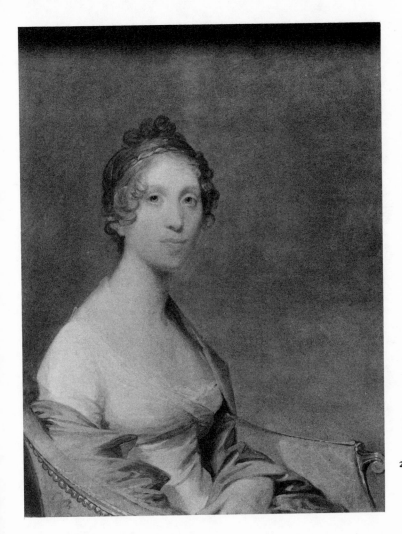

2. MRS. JOSIAH QUINCEY
 Gilbert Stuart Oil on canvas 1806
 Frederic R. Nourse, Jr., and Mrs. E. L. Beckwith Collection
 Courtesy, John Howard Joynt Collection

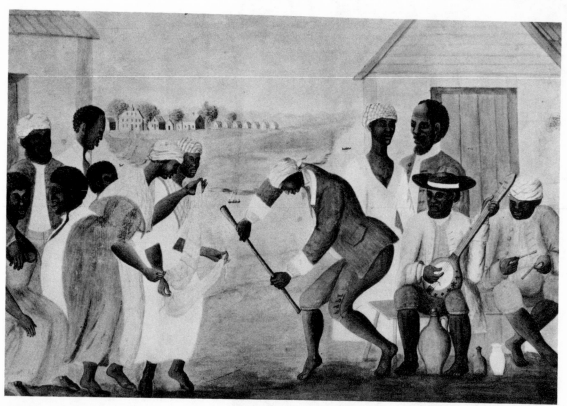

3. THE OLD PLANTATION
Watercolor c.1800

Rockefeller Collection, Williamsburg

4. OLD KENTUCKY HOME
Eastman Johnson Oil on canvas 1859

New York Public Library

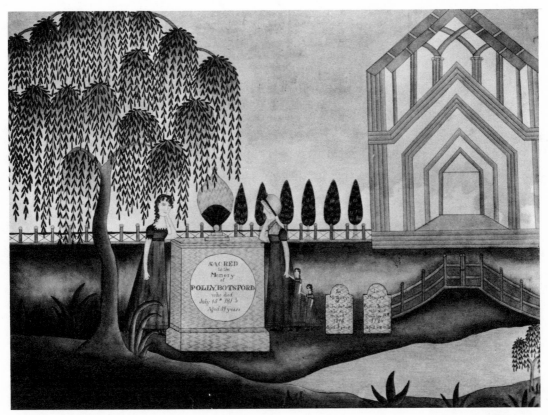

5. MEMORIAL FOR POLLY BOTSFORD
Watercolor 1813

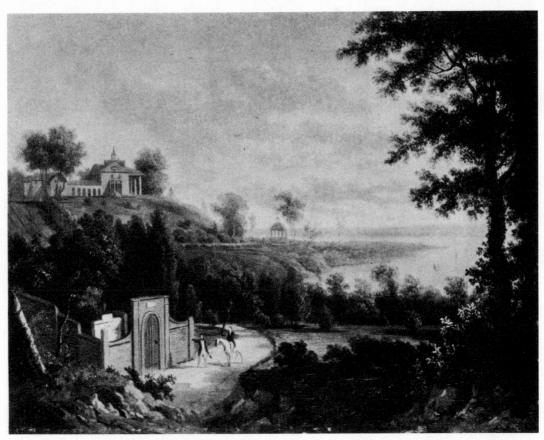

6. WASHINGTON'S TOMB AND MT. VERNON
W. H. Bartlett Oil on canvas Mid 19th century

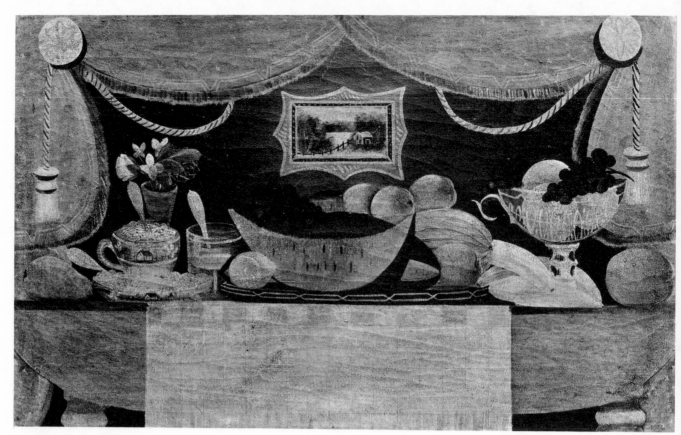

7. THE BOUNTIFUL BOARD
Oil on bed ticking c.1800

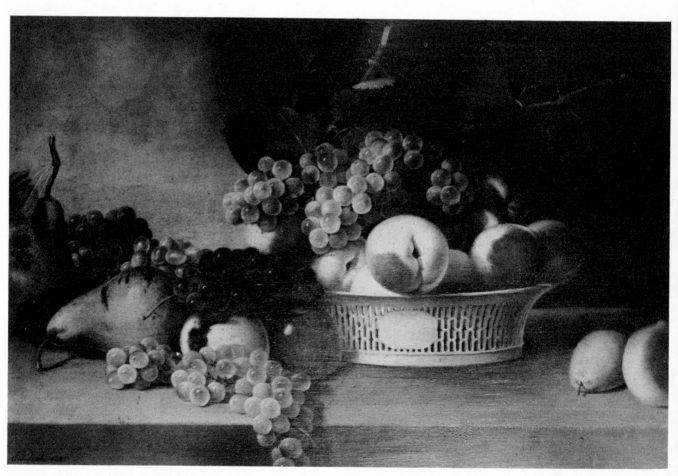

8. STILL LIFE
James Peale Oil on canvas c.1820

COLOR PLATES

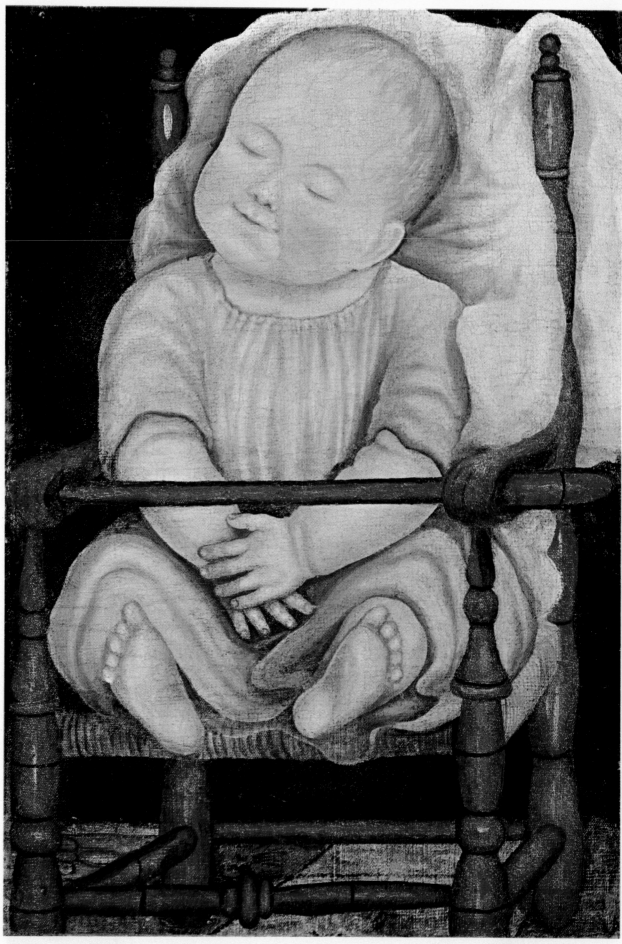

9. BABY IN RED HIGH CHAIR
Oil on canvas c.1790

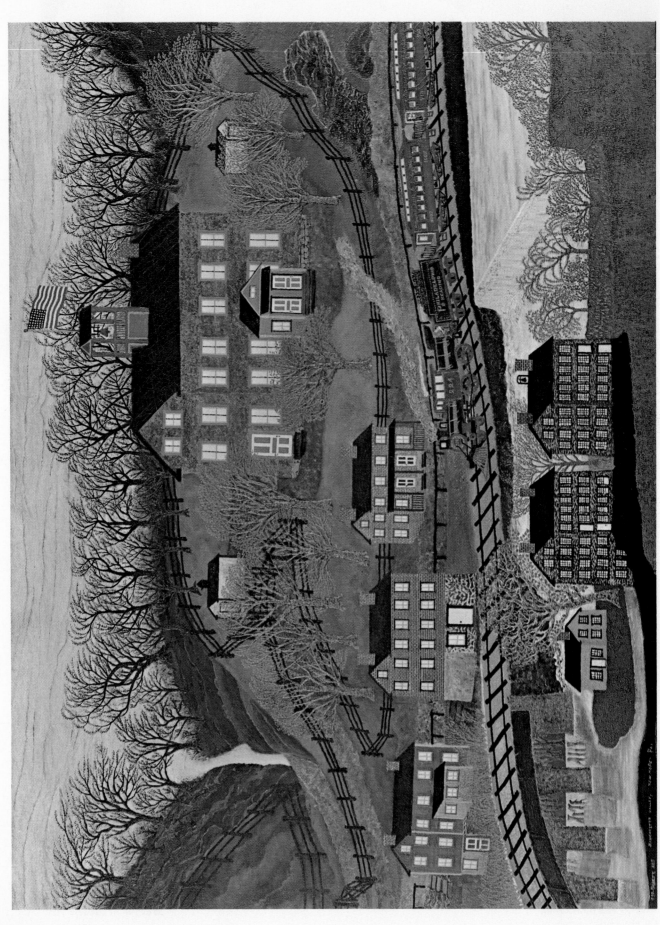

45. MANCHESTER VALLEY
Joseph Pickett Oil on canvas 1914-18 (?)

48. WINTER SUNDAY IN NORWAY, MAINE
Oil on canvas c.1870

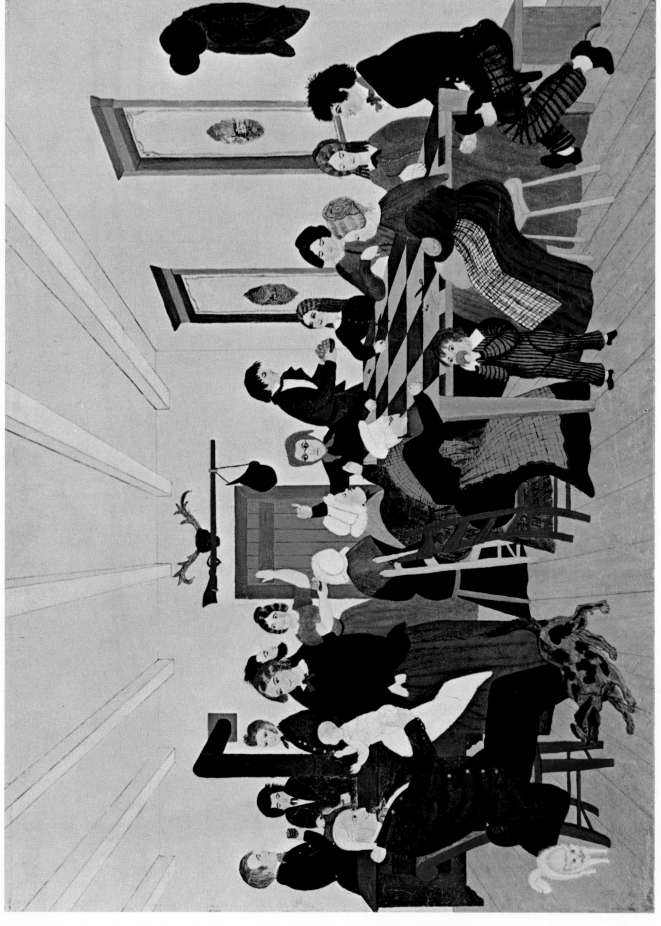

Museum of Modern Art

Courtesy, Rockefeller Collection, Williamsburg

51. THE QUILTING PARTY

Oil on wood 1840–50

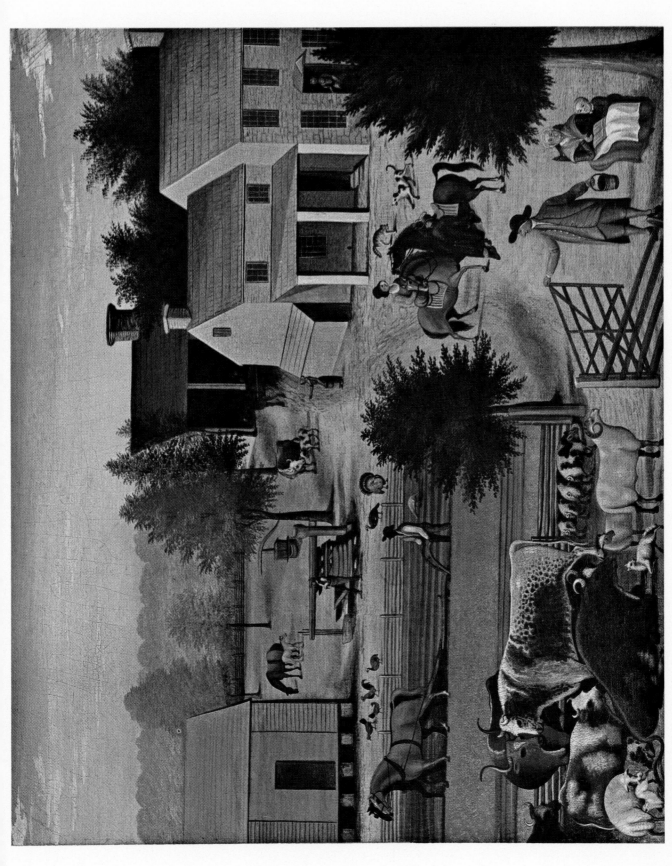

57. 'THE RESIDENCE OF DAVID TWINING IN 1787' *Museum of Modern Art*
Edward Hicks Oil on canvas Early 19th century *Courtesy, Rockefeller Collection, Williamsburg*

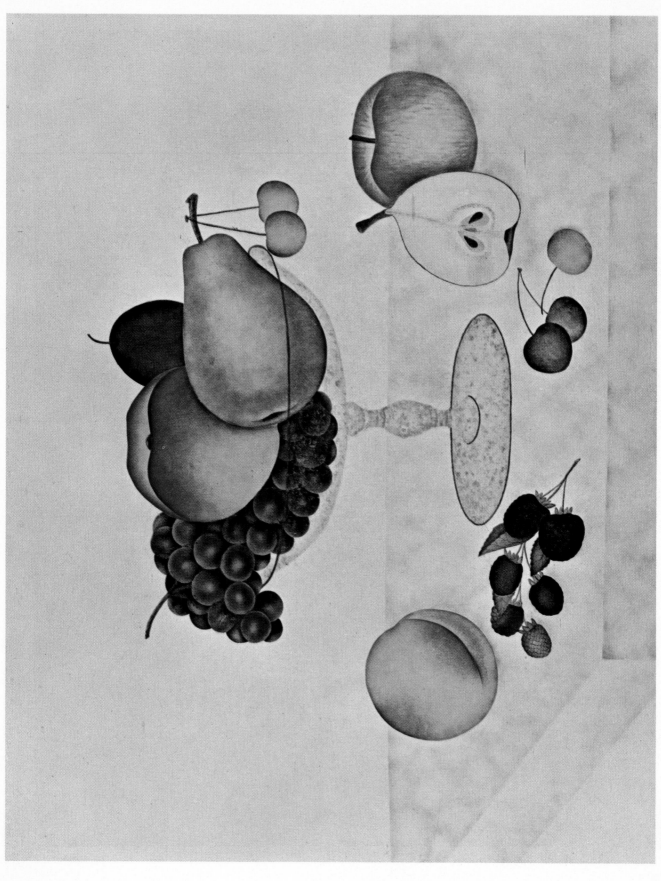

79. STILL LIFE
Emma Cady Watercolor c.1820

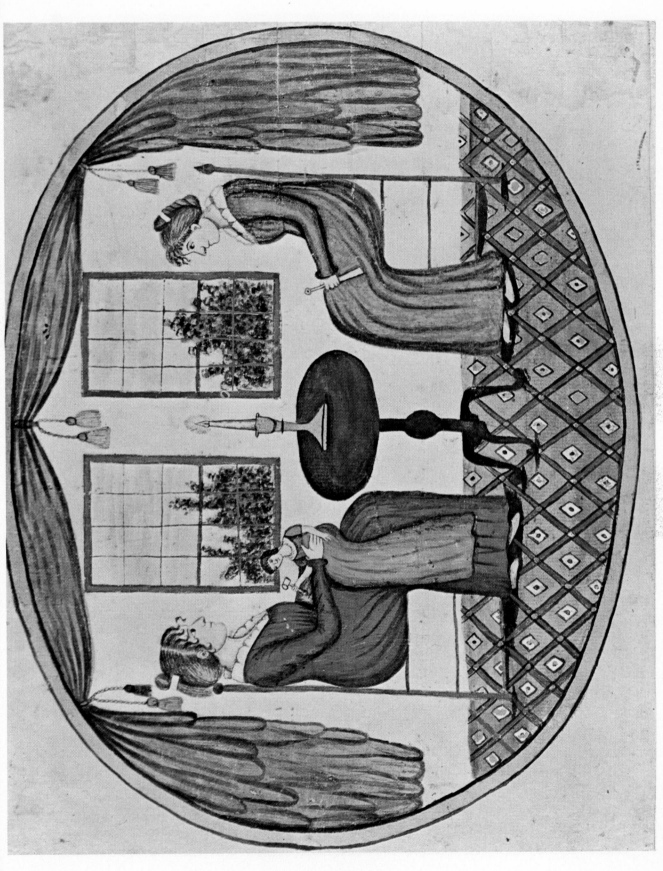

85. TWO WOMEN
Eunice Pinney Watercolor c.1815

89. 'THE RESIDENCE OF GEN. WASHINGTON MT. VERNON VIR.
PAINTED BY SUSAN WHITCOMB AT THE LIT. SCI. INSTITUTION, BRANDON, VT. 1842'
Watercolor

Rockefeller Collection, Williamsburg

Portraiture—A Revaluation

MANY art forms highly valued today were a generation ago, as we have remarked, ignored or negatively criticized as childish and crude; and modern abstract art did not exist. The standard was then visual plausibility achieved through technical dexterity. To say that modern criticism has acknowledged the aesthetic qualities of primitive and abstract art is an understatement. The key aspect of contemporary taste is the high value set on the abstract at the expense of the realistic approach to painting. There has been a complete reversal of standards. Academicism and verisimilitude have come to be judged negatively as diluting the intensity of perception, obscuring the personal point of view, preventing selectiveness and subordination and the fresh direct conveying of an idea —in other words, spoiling the major possibilities of abstraction.

In this aesthetic revaluation there has, however, been a surprising critical lag in the field of early American painting. The native abstract tradition in American painting has heretofore been slighted by the critics to an extraordinary degree. Particularly in the field of portraiture, what is most distinctive and unique in American painting awaits clearer definition and more general appreciation because of the academic English tradition having dominated the native style almost from the beginning. Most critics have consistently based their estimates on academic English or Continental standards, naming those American painters the greatest who were the least American and most imitative in their approach. The

(17)

bold, abstract American style has been criticized as lacking in finesse of characterization and in subtlety of coloring and design. It is a strange blindness that has caused these critics to look for skilled academic refinement in the art of a sturdy pioneering people who had colonized a wilderness through fresh vigorous enterprise and robust vitality—qualities with which their native art was necessarily endowed. But, as Willard Huntington Wright commented in his *Misinforming a Nation*, 'In our slavish imitation of England—the only country in Europe of which we have any intimate knowledge—we have de-Americanized ourselves to such an extent that there has grown up in us a typical British contempt for our own native achievements.'

World affairs today, creating a conscious Americanism in this country, have paved the way for a timely artistic revaluation in which primitive painting, so purely of the American tradition, plays an increasingly important part. Its merits have been recognized for some years, and it would be foolish to hail it as a new discovery. But the time is ripe for considering American primitive painting not as an isolated phenomenon, but as an essential and integral part of America's artistic development. The basic characteristics of the outstanding primitive portraits are those of the most typically American portraits. Certainly the time will come when an outstanding primitive by a gifted unsophisticate will hold its own with any academic portrait.

The fact that primitive portraiture reached its height in the nineteenth century rather than in the more 'primitive' seventeenth and eighteenth centuries indicates that the native trend was at first submerged by traditional European styles and then eventually achieved independent development.

It cannot be sufficiently stressed that the style of the American Primitive is essentially intellectual and abstract—not 'quaint'—and that it represents the very essence of abstract design, which is the opposite of illusionistic realism.

The typical primitive portrait — whether executed in oil, pastel, or watercolor, and whether on canvas, bed-ticking, wood, paper, or glass—is first of all characterized by a strong sense of design which dominates the whole and controls

every part. Each part of the portrait is conceived as a distinct unit, all of which add up to form a decorative and broadly descriptive composition. It was quite consistent with his general attitude, as we have pointed out, for the itinerant limner to paint a number of attractively dressed bodies, then complete them with individual heads as customers were found, with no attempt to portray the sitter naturalistically (see Plate 20). The painter, visualizing his sitters generically as well as individually, would usually include in each portrait distinguishing symbols, appropriate to his subject—binoculars for a sea captain, a shelf of apothecary bottles for a doctor, pet cat or dog, hobby horse or doll for a child, paintbox or rose for a lady, half-open Bible for a clergyman. It is tempting at this point to quote Mark Twain's description, in *Life on the Mississippi,* of a typical portrait found in 'The House Beautiful' in 1874:

In big gilt frame, slander of the family in oil: papa holding a book ('Constitution of the United States'); guitar leaning against mamma, blue ribbons fluttering from its neck; the young ladies, as children, in slippers and scalloped pantalettes, one embracing toy horse, the other beguiling kitten with ball of yarn, and both simpering up at mamma, who simpers back. These persons all fresh, raw, and red—apparently skinned.

And here is the first critical estimate of American Primitive portraiture, written in 1842 by Charles Dickens as he described in his *American Notes* an inn in the village of Lebanon, Ohio:

In the best room were two oil portraits of the kit-cat size, representing the landlord and his infant son; both looking as bold as lions, and staring out of the canvas with an intensity that would have been cheap at any price. They were painted, I think, by the artist who had touched up the Belleville doors with red and gold; for I seemed to recognize his style immediately.

Let us look at a few of the early nineteenth-century paintings reproduced as typical examples of this homespun approach to portraiture.

The portrait of Eliza Smith, schoolmistress, painted in 1832 by the pastor of Broad Street Christian Church in Johnson, Rhode Island, vividly discloses the attitude of a non-professional painter (Plate 24). Miss Smith is seated on a chair which rests in what appears to be a shallow box, but which on second glance is revealed as a unique abstraction of a carpeted room. She and the telescoped sec-

tion of room are set against a dusky scenic backdrop in which the pastor's church and Miss Smith's school are prominently placed as descriptive attributes of painter and sitter. Another detail indicative of method is the clasped hands, which clearly show that the sprays of moss rose were painted as a decorative afterthought with no attempt at a functional rearrangement of the hands.

The York Family at Home, dated 1837 (Plate 30), shows the manner in which single elements of design add up to create a decorative whole, bringing the art of portraiture close to that of still life. In rigidly symmetrical arrangement selected attributes of the family and their home are displayed. The symbols of this home include 'Thomas York, aged 50, Harriet York, aged 26, Julia Ann York, 4 months,' the Holy Bible, vase of flowers, cat, framed picture, morning paper, and high hat. The all-pervasive sense of design, which animates each detail of table, chair, dress, and rug, overflows in the exuberant calligraphic flourishes of the caption. It is interesting to note here that several other versions of this same composition have been found, one representing the Tuttle family, now in the New York Historical Society, one of the Demeritt family in the collection of Mrs. Albert Boni and another in the collection of Holger Cahill. Except for the faces and captions these four watercolors are identical in almost every detail. This is a striking example of the itinerant's habit of preparing well in advance for his individual customers, and reveals both his attitude and that of his sitters concerning the art of portraiture. Consistent realism was obviously not considered necessary.

In the very different *New Bedford Memorial Group* (Plate 31) a decorative flower border is an integral and strikingly abstract element of design, as are the nine yellow stars which symbolize the nine members of this family rigidly lined up among strange, gigantic flowering plants.

In an early portrait of a brother and sister by J. N. Eaton (Plate 13) pose and gesture illustrate in the manner of the early illustrated children's books a prim text inscribed at the base:

W. See what a pretty bunch I've found,Mary!
M. So you have William, will you let me have them?

The inclusion of caption and text in the body of the picture provides one more witness to the primitive's typically unillusionistic approach to painting. In this picture the sharp linear contour is an important stylistic element. It is a decorative and descriptive agent which firmly outlines shapes but puts the butterflies, birds, plants, a strange landscape cut by a stream, and the two Buddha-like children into a two dimensional world.

The Ellsworth double portrait (Plate 38) shows the characteristic manner in which a decorative formula was applied by an eccentric primitive miniaturist. The rigidly symmetrical poses, the incorporation of the frame in the design, the odd clover-leaf foils for the heads and bodies are all elements of a highly stylized conception of portraiture. Ellsworth was primarily concerned with design; though well able to paint with verisimilitude, he limited himself to a realistic rendering of the faces so as not to interrupt the design of the whole.

In the pastel portraits of Frederic and Harriet Parker (Plate 17) the painter has boldly recorded the fundamental attributes of his sitters instead of trying to catch transitory details of expression or gesture. The pose and expression of the heads is almost neutral. It is the accessories of squirrel-on-a-chain and bowl of nuts for the boy and paintbox and rose for the girl, his gay figured waistcoat and nice bow tie and her staccato jewelry and spiral curls that hold our interest. The finely balanced decoration of a painted surface, rather than the penetration of character or real appearance, was the unconscious achievement of this able draughtsman.

PORTRAITS

FAMILY GROUPS

MINIATURE PORTRAITS

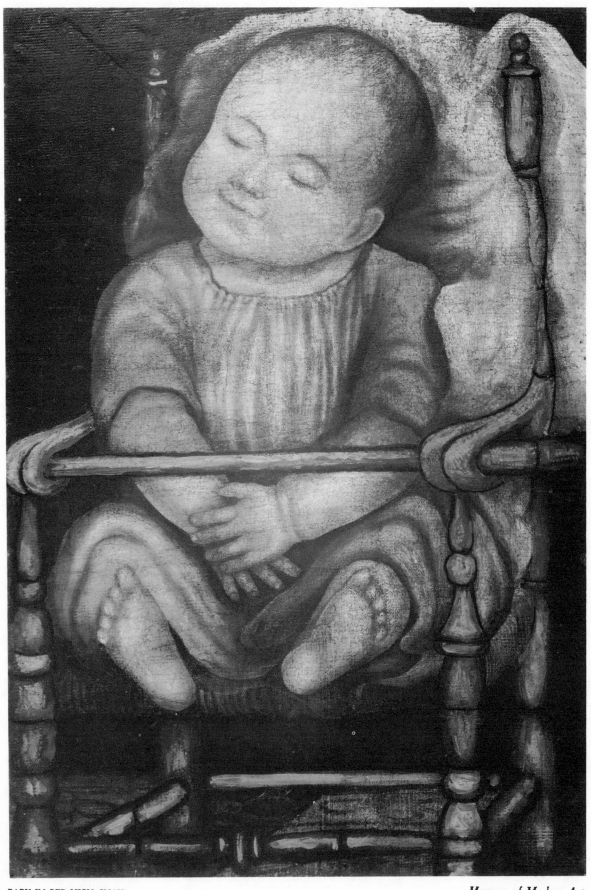

9. BABY IN RED HIGH CHAIR

Oil on canvas c.1790

Museum of Modern Art
Courtesy, Rockefeller Collection, Williamsburg

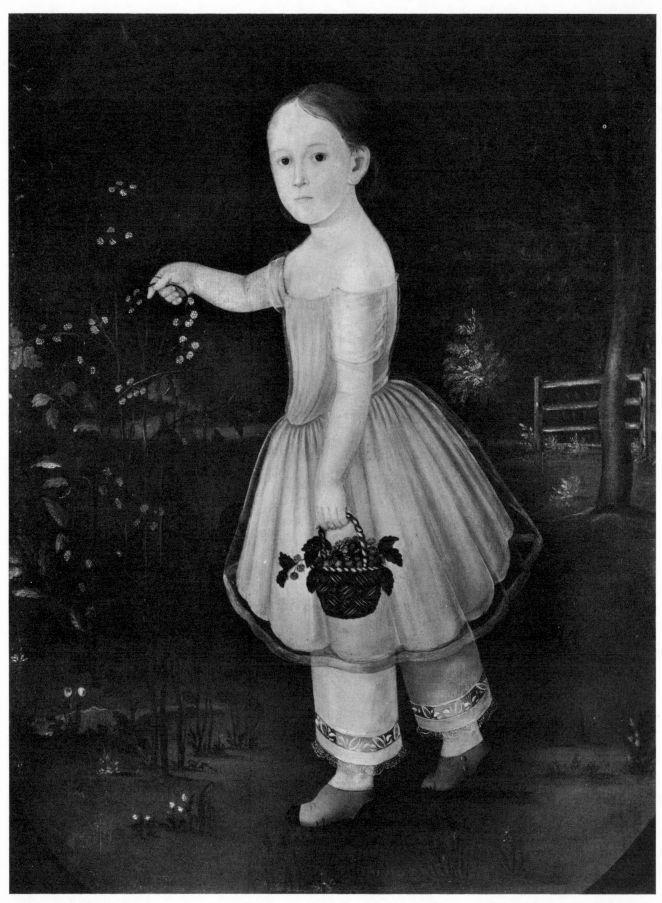

10. PICKING BERRIES
Oil on canvas Mid 19th century

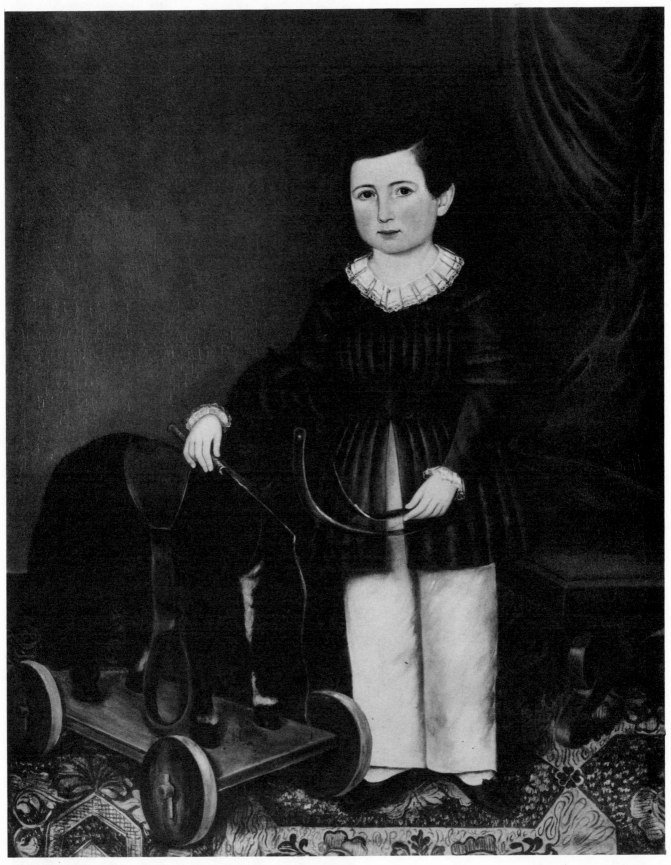

11. BOY WITH HOBBYHORSE

Joseph W. Stock Oil on canvas Mid 19th century

New York Historical Society

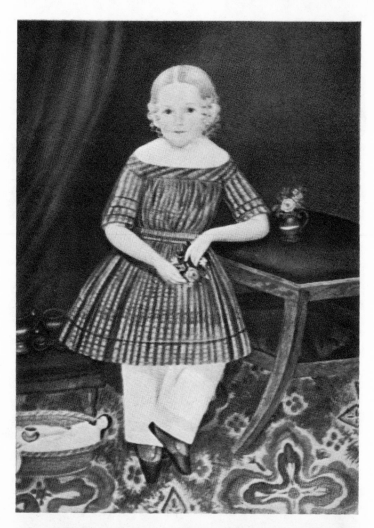

12. MARY AND SUSAN CHILDS
 Joseph W. Stock Oil on canvas Mid 19th century
 Mary P. Thayer Collection

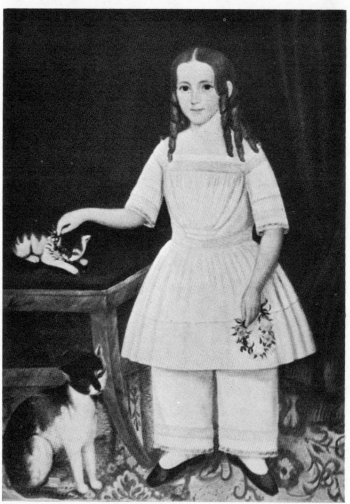

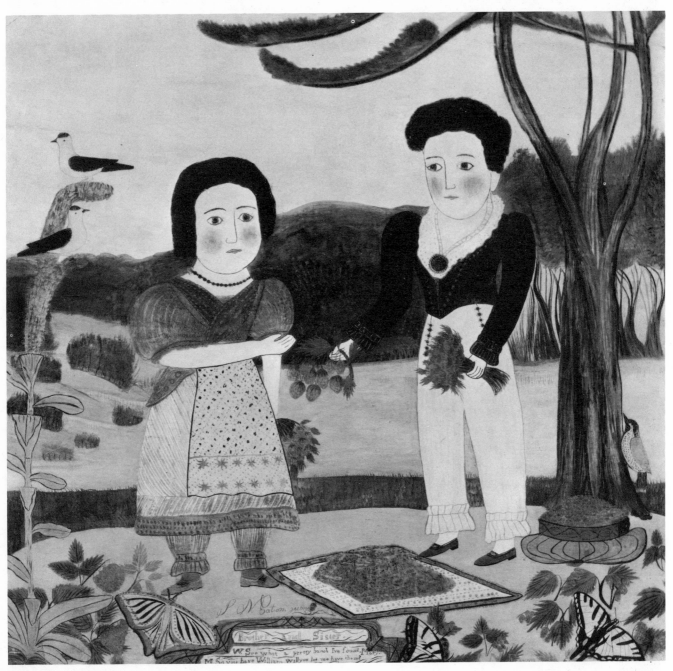

13. CONVERSATION PIECE
 J. N. Eaton Oil on wood c.1800

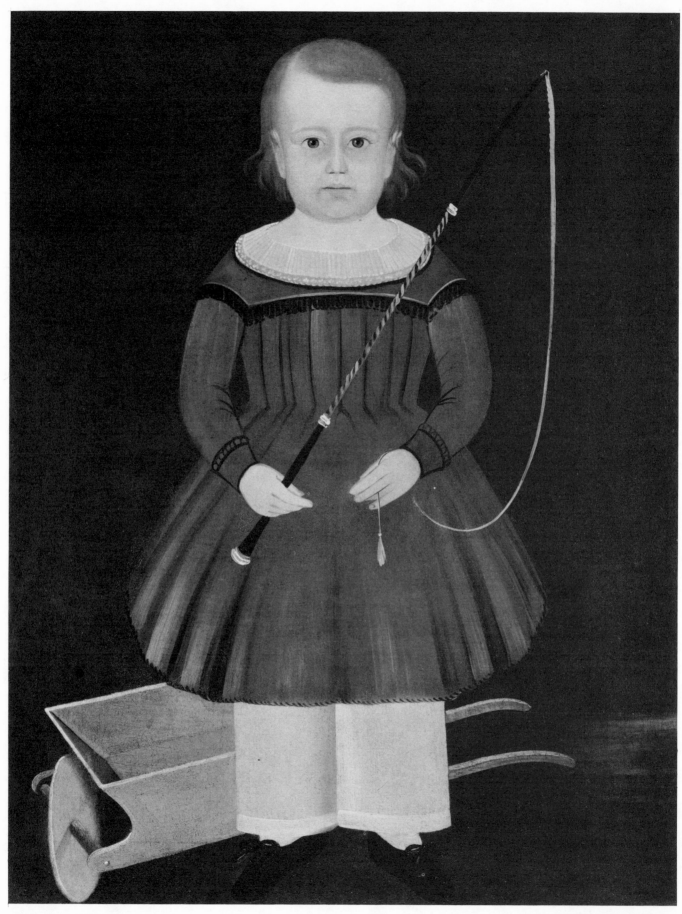

14. BOY WITH TOY CART
Oil on canvas Early 19th century

Holger Cahill Collection

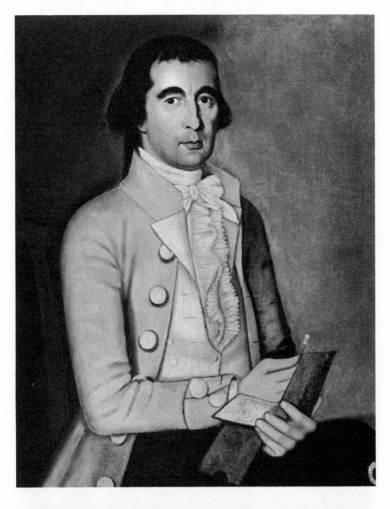

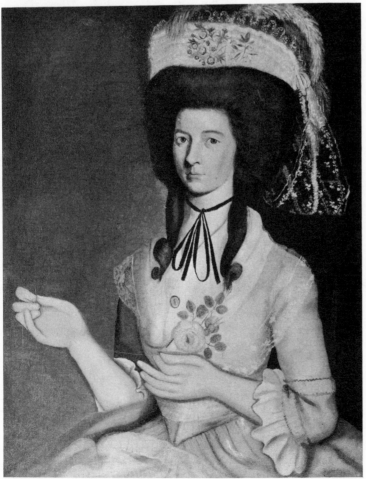

15. MR. AND MRS. MIX OF CONNECTICUT
McKay Oil on canvas 1788
Rockefeller Collection, Williamsburg

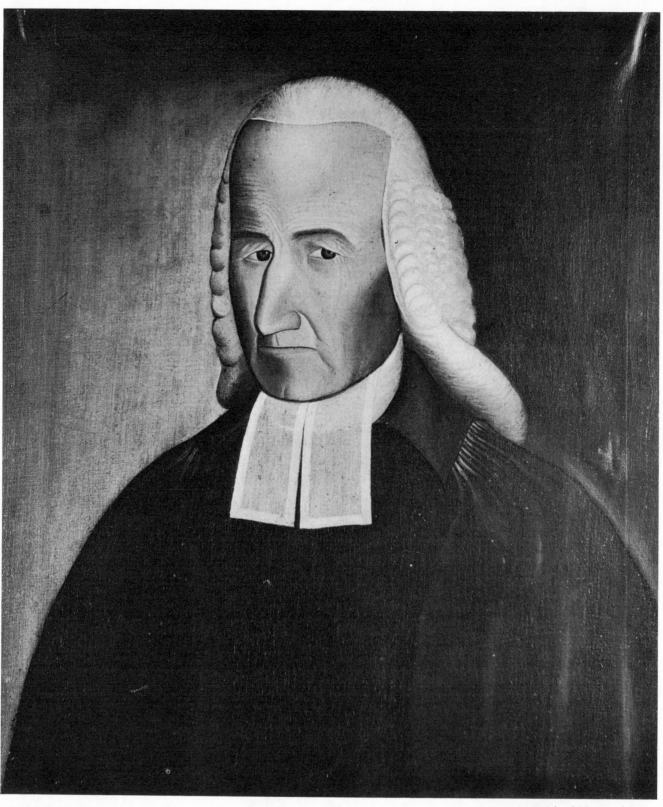

16. REV. SAMUEL BUELL
 Oil on canvas Late 18th century

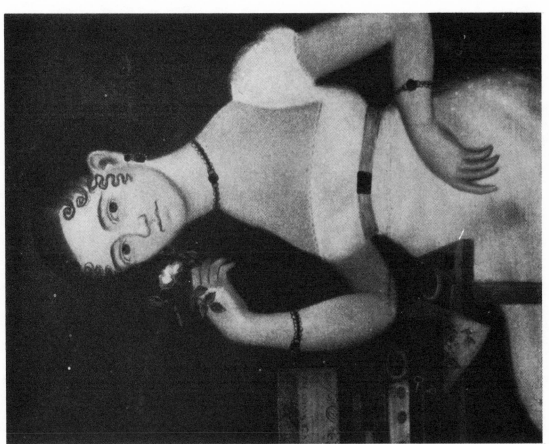

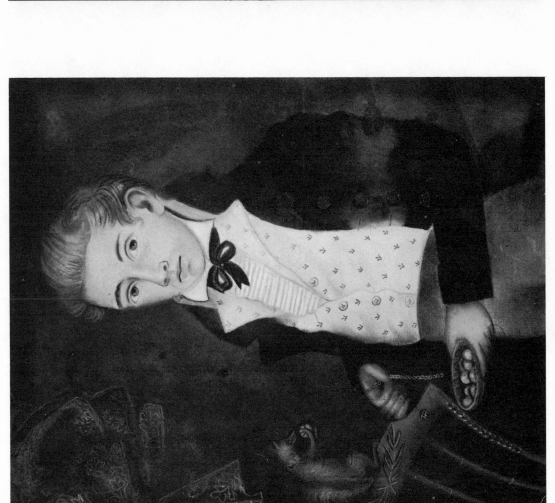

17. FREDERIC AND HARRIET PARKER OF PEPPERELL, MASS.
Pastel c.1815

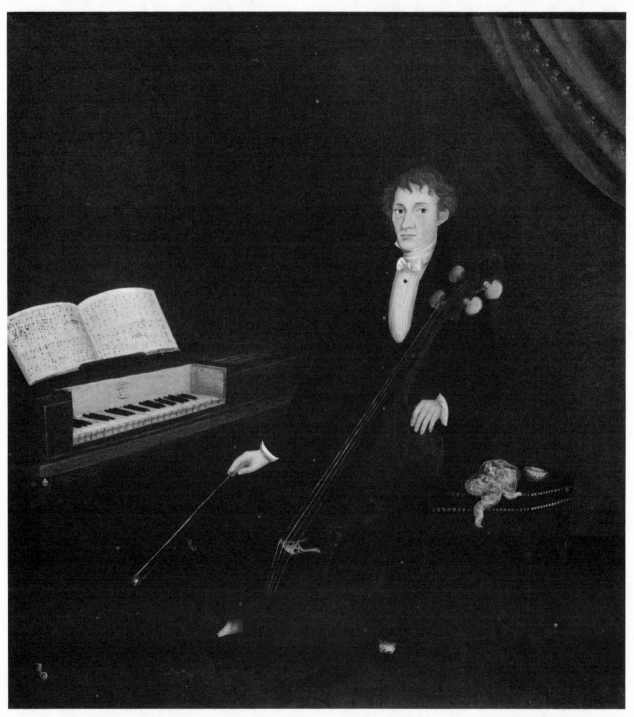

18. CELLIST
 I. Bradley Oil on canvas 1832

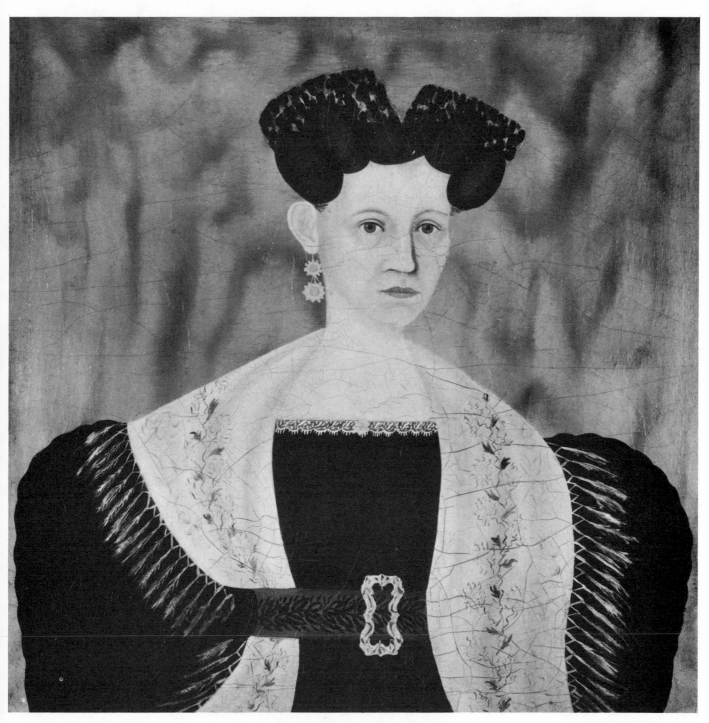

PORTRAIT OF A LADY
Oil on canvas Early 19th century

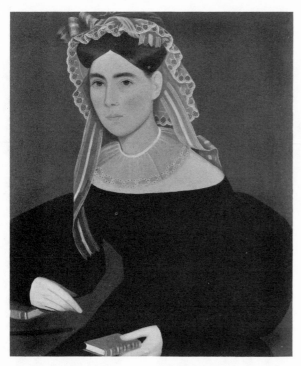

UNIDENTIFIED LADY *Harry Stone, New York*

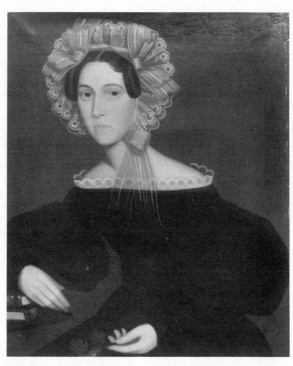

MRS. JULIA FULLER BARNUM *Mary A. Hopson Collection*

20. Three stock bodies completed with individual heads—painted by an itinerant limner of Kent, Connecticut, c. 1840

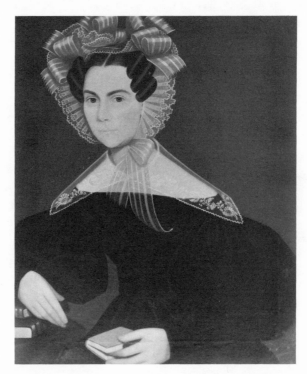

MRS. ALMIRA PERRY *Mrs. H. B. Britton Collection*

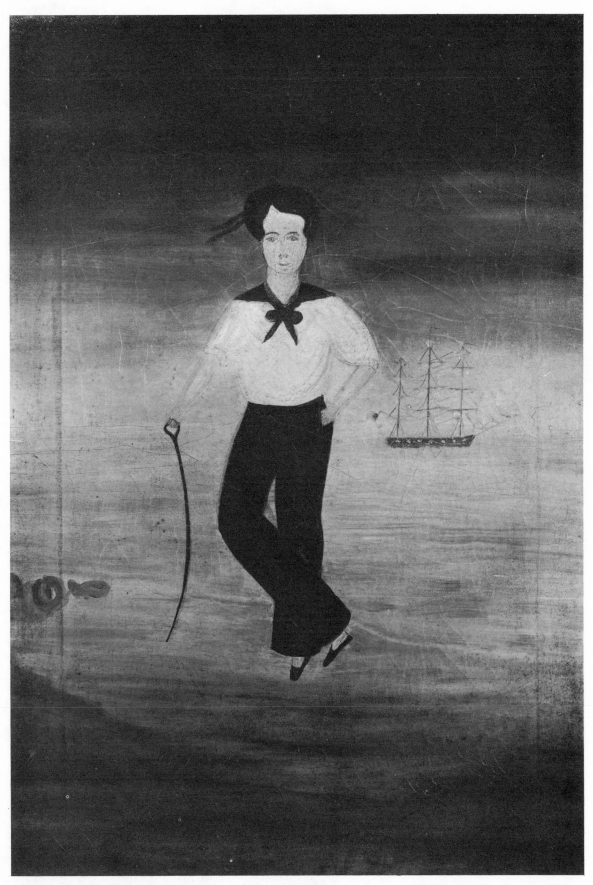

21. SAILOR
Oil on canvas Early 19th century

Walter P. Chrysler, Jr., Collection

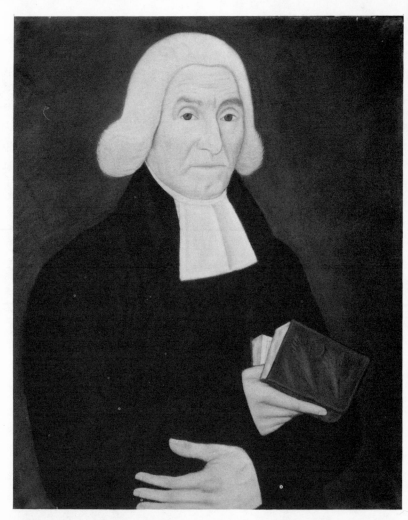

22. REV. BENJAMIN DU BOIS AND PHOEBE DE NISE DU BOIS
Pastel Late 18th century
Cincinnati Museum of Art

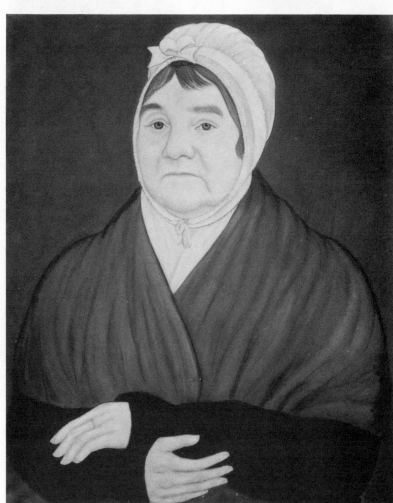

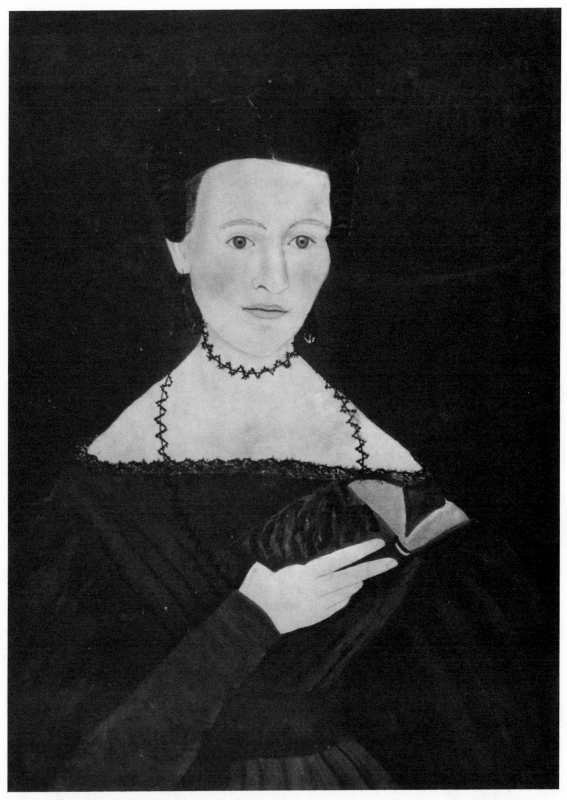

23. NEW ENGLAND WOMAN
Pastel and watercolor Early 19th century

New York Historical Society

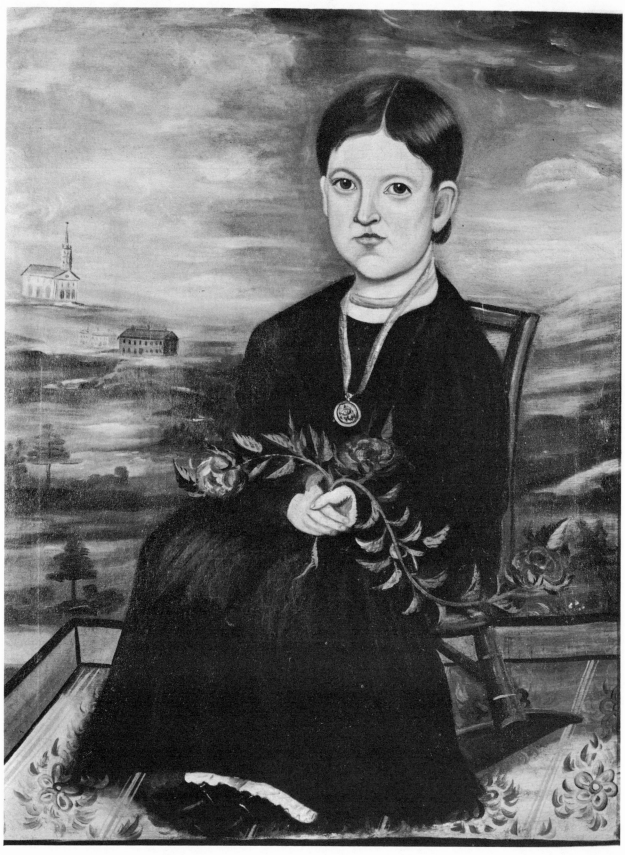

24. ELIZA SMITH, PROVIDENCE SCHOOLMISTRESS
Oil on canvas 1832

Collection of the author
Courtesy, New York State Historical Association, Cooperstown

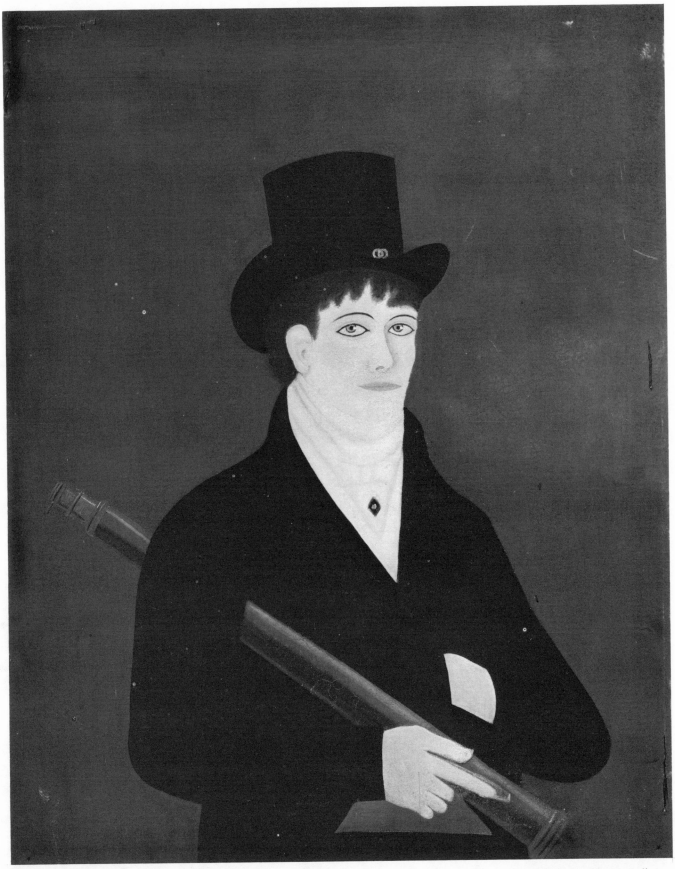

25. CAPTAIN THOMAS BAKER OF KENNYBUNKPORT, ME.
Oil on canvas c.1800

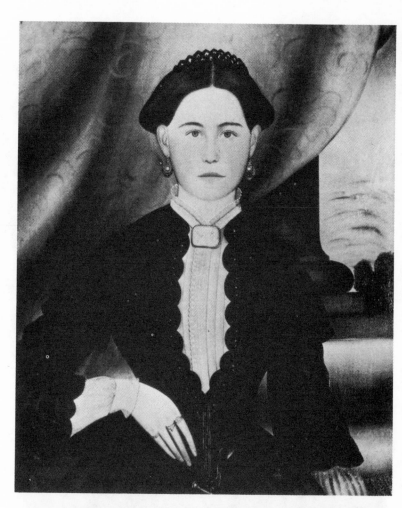

26. LADY AND GENTLEMAN OF STURBRIDGE, MASS.
Oil on canvas Early 19th century
Fruitlands and the Wayside Museums, Harvard, Mass.

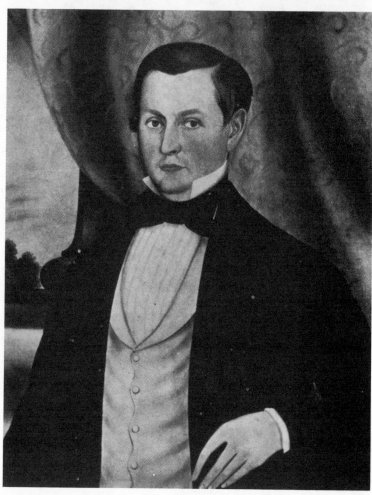

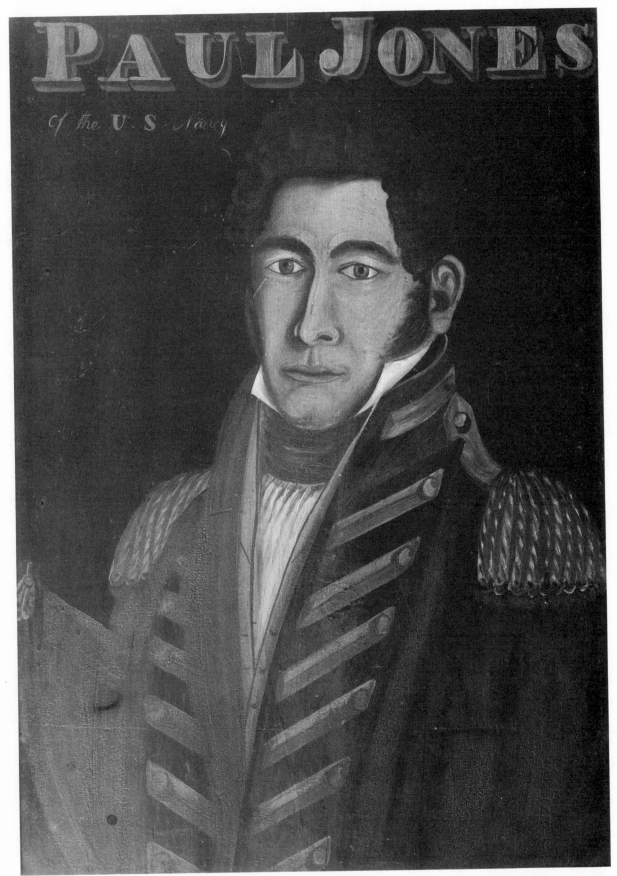

27. 'PAUL JONES OF THE U. S. NAVY'
Oil on wood Early 19th century

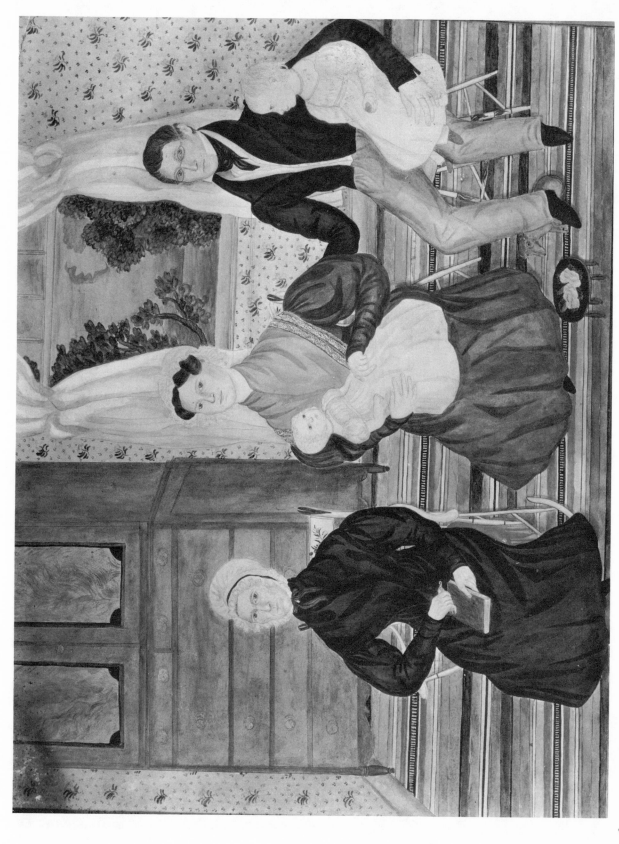

28. THE TALCOTT FAMILY
D. Goldsmith Watercolor 1832

Mrs. John Law Robertson Collection

29. THE BROWN FAMILY Mid 19th century
Oil on canvas

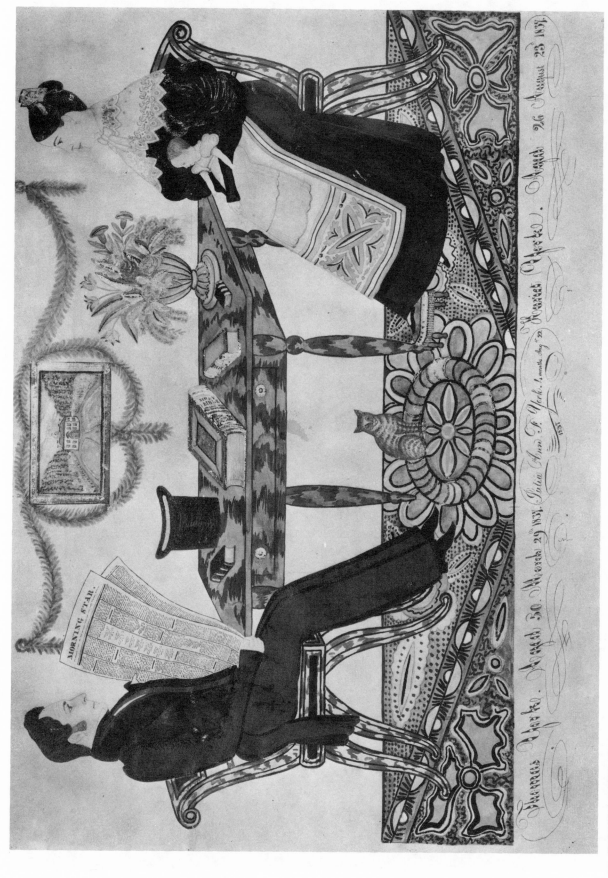

30. THE YORK FAMILY AT HOME
Watercolor 1837

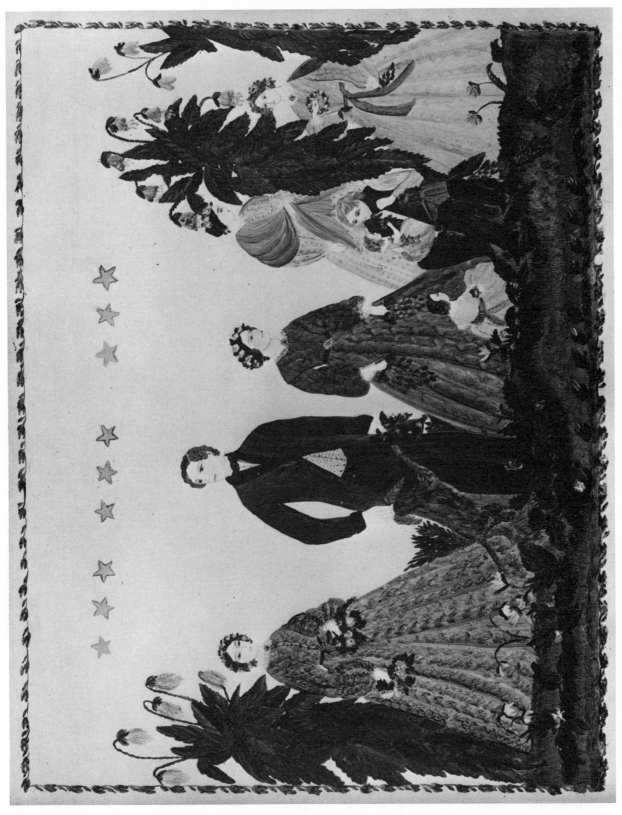

Collection of the author

31. NEW BEDFORD MEMORIAL GROUP c.1840
Oil on cardboard

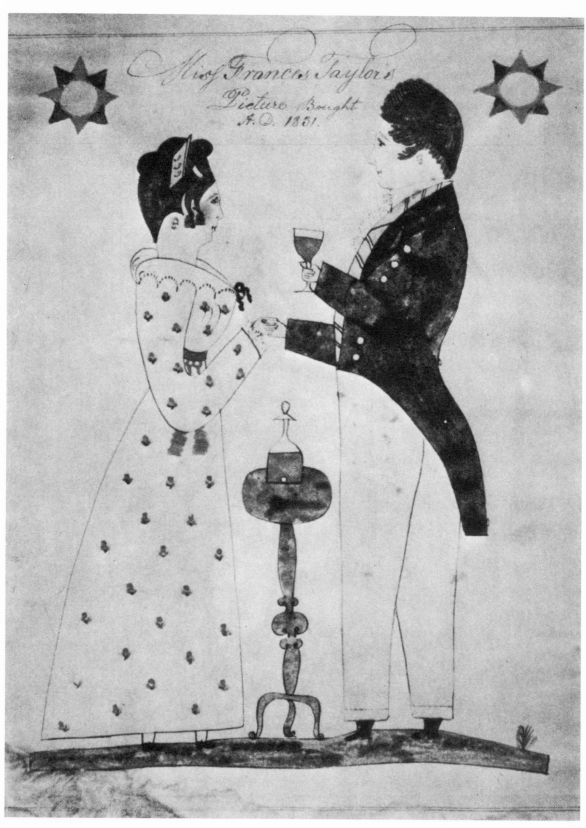

32. MISS FRANCES TAYLOR
Pennsylvania watercolor 1831

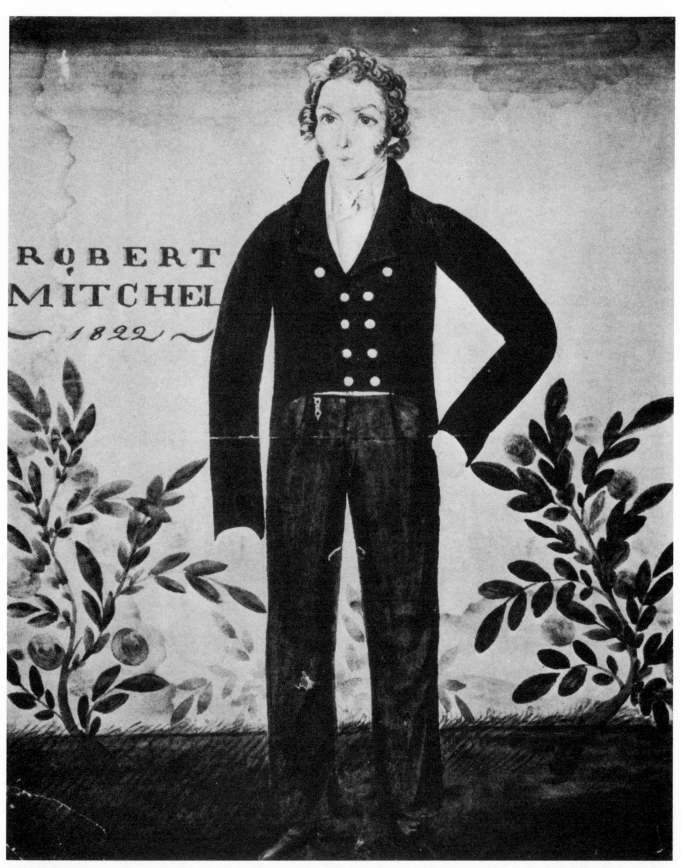

33. ROBERT MITCHEL OF CONNECTICUT *Alfred E. Hamill Collection*
Watercolor 1822

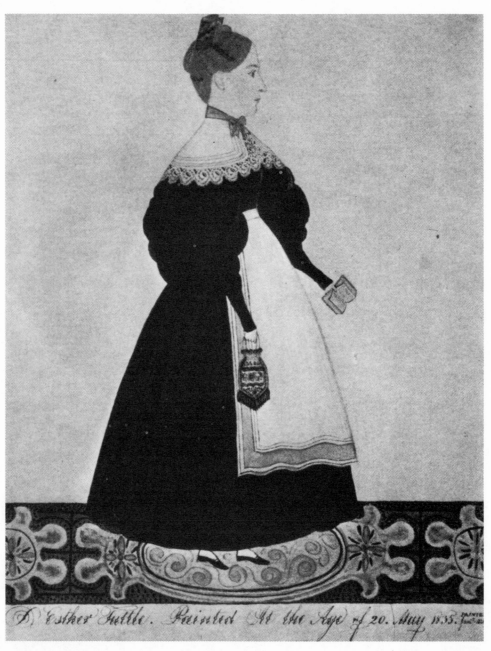

34. ESTHER TUTTLE *New York Historical Society*
 Watercolor 1836

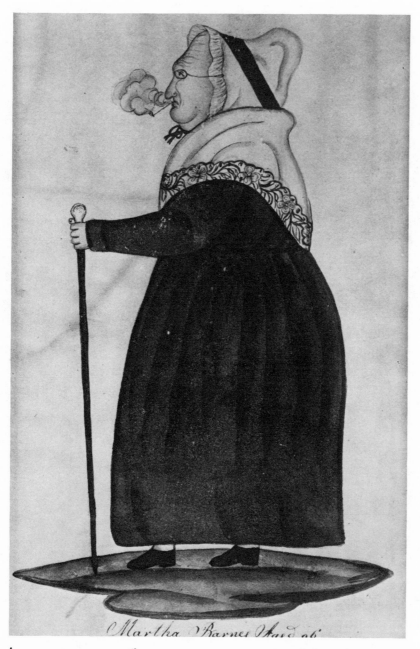

35. 'MARTHA BARNES AGED 96' *Collection of the author*
 Lucius Barnes Watercolor c.1834

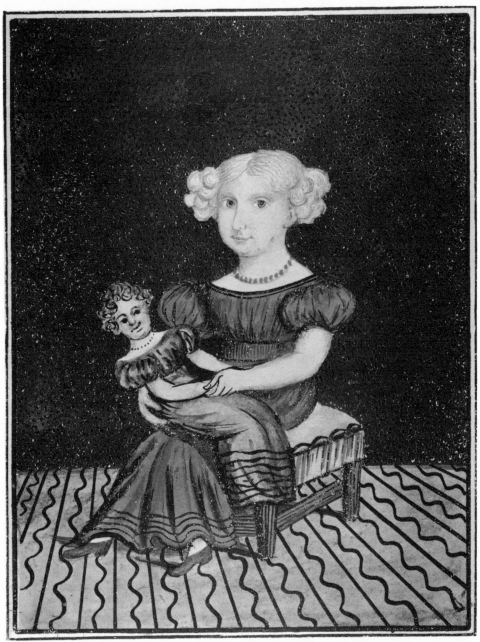

36. EDNA CLARK
Watercolor 1829

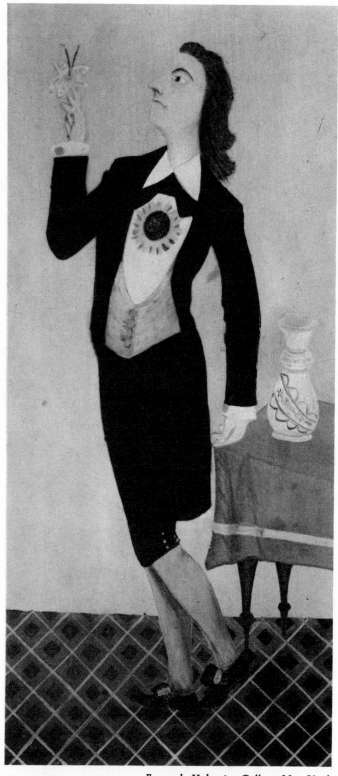

37. OSCAR WILDE *Formerly Valentine Gallery, New York*
Oil on wood c.1882

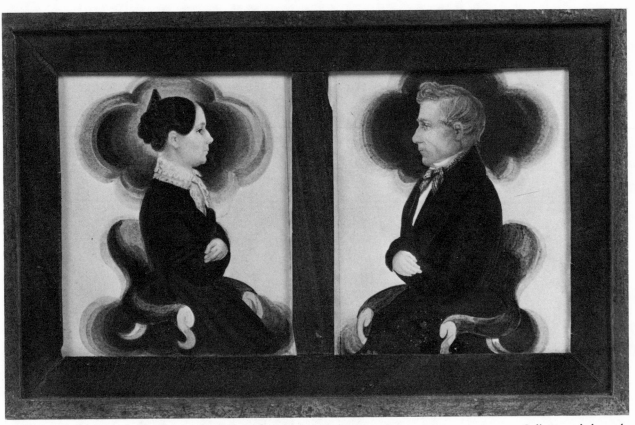

38. Above: CONNECTICUT GENTLEMAN AND HIS WIFE 1852
 Below: JENNIE POST OF GUILFORD, CONN. c.1835
 Watercolor Miniatures by James Sanford Ellsworth

The Composite Scene

THE 'scene' pictures in American primitive painting include landscapes, genre, historical and Biblical scenes, and ship pictures. But despite the seemingly varied approaches to this subject matter, the presentation, under the primitive painter's hand, is strikingly homogeneous. The historical and religious scenes, for instance, are really genre. Achieving a true historical perspective was not possible for the primitive painter, any more than was a true visual perspective. His scenes are always abstractly conceived, in the sense we have defined, and are based primarily upon his own experiences. As in his portraiture, the specific subject matter is no more than a point of departure. The finished design is more closely related to the painter's mental picture than to that presented by either a model, nature, or a historical document.

The primitive artist, lacking the academic training which would have enabled him to paint scientifically and realistically, either from nature or a verbal description of fact or fiction, painted with a fine indifference to exact visual appearance. And, being independent of the casual shifting appearances of reality, he was free to organize and stabilize his composition from the point of view of design. In any primitive landscape, genre, or historical scene the binding agent is design rather than a realistically consistent perspective or enveloping atmosphere, both of which are notably missing in primitive pictures. The omission of aerial perspective largely accounts for the much remarked 'clarity' of primitive pictures, while emphatic

design in place of our familiar academic perspective largely explains their 'originality.'

As the primitive painter did not attempt to recreate any specific moment of visible reality, his vision was generalized, timeless. The scene he painted was always —and this is the most significant characteristic of a Primitive—a composite scene. It was composed of a number of separately remembered units which added up to construct the whole. This explains the seemingly contradictory but basically consistent fact that in primitive painting one finds some overcrowded, feverishly active scenes and others in which the elements of the composition are isolated, the ground almost empty, the action seemingly petrified. Both of these possibilities result from a selection and addition of the typical elements in any typical situation, and whether the artist chose to include more elements and activities or less than would be possible in any real scene is immaterial; both oppose the one possibility that was outside the pale of the primitive painter—a representation of normal visible reality.

Contrasting manifestations of the same abstract attitude are clearly seen in the *Darkytown* (Plate 50) and the remarkable *Quilting Party* (Plate 51). In the former the carefully selected attributes of a typical scene are immobilized in startling isolation against an almost undifferentiated background. The mental processes of a primitive painter can here be clearly followed. One senses that each figure and group existed as a typical memory-image in the artist's mind and that he set them down in paint in the same precise arrested poses in which they existed in his mind's eye. The figures bear no more optical relationship to their background space than if they had been cut-out silhouettes pasted upon it—yet what an extraordinary rhythmical arrangement holds them together! It is apparent that this picture is as noteworthy for what the artist omitted as for what he included. In the quilting scene every activity possible to such an occasion, every pertinent gesture and pose, are combined within the crowded space of the represented room. Cat-and-dog-fight, old man holding baby, women sewing, boy eating apple, couple holding hands, man passing fruit, another pouring drink—the action

encompasses all possibilities, which of course could never have been so synchronized at any given moment. The effect of sharp movement into the room created by the outlines of the floor boards and rafters, the staccato pattern of the checkered quilt, and the tonal movement of the whole complex composition offers interesting contrast to the *Darkytown,* whose widely spaced vertical figures intersect the neutral background as crisply as notes set in a scale of music.

The abstract attitude inherent in the composite scene when carried to its logical extreme not only caused the artist to create a scene out of either more or less elements than were realistically possible, but permitted him to include within one picture-area units representing different times or places—again of elements which would never have been juxtaposed by an artist with any realistic attitude towards his painting. A Hicks *Peaceable Kingdom* (Plate 65), with the historical scene of Penn's Treaty with the Indians represented in one portion, the Biblical menagerie in another, is a familiar example of this radically unacademic attitude.

The composite scene is one common denominator for primitive painting of all ages. It exists in Egyptian wall paintings, Greek vase paintings, Italian quattrocento panels, in Henri Rousseau, and in the American Primitives; and for the consciously primitivistic moderns from the great Expressionists to Grant Wood, the composite scene with all its implications is fundamental.

LANDSCAPE

GENRE

BIBLICAL AND HISTORICAL SCENES

SHIP PICTURES

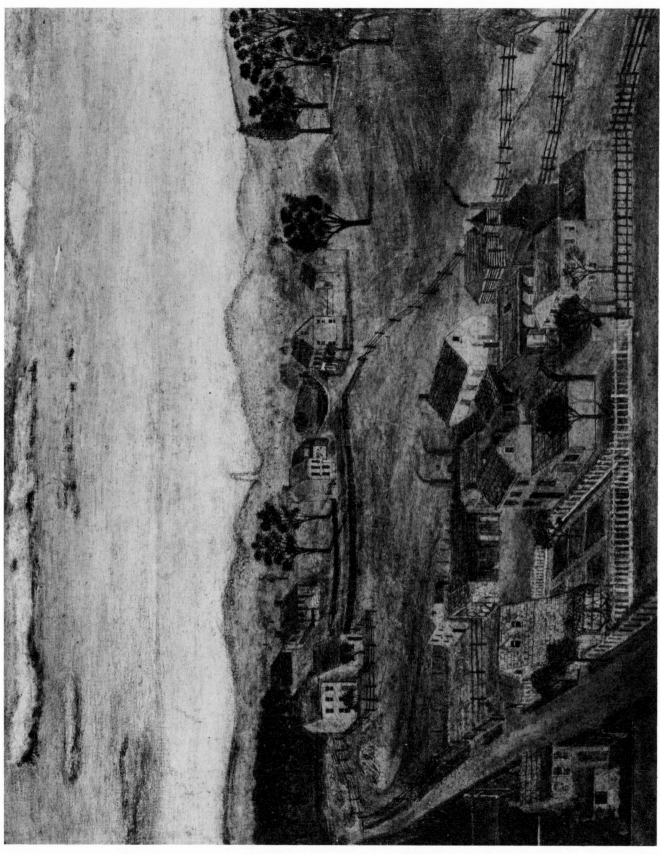

39. EARLY NEW ENGLAND FACTORY VILLAGE *Courtesy Horace W. Davis Collection*
 Oil on canvas c.1830 *Courtesy, New York State Historical Association, Cooperstown*

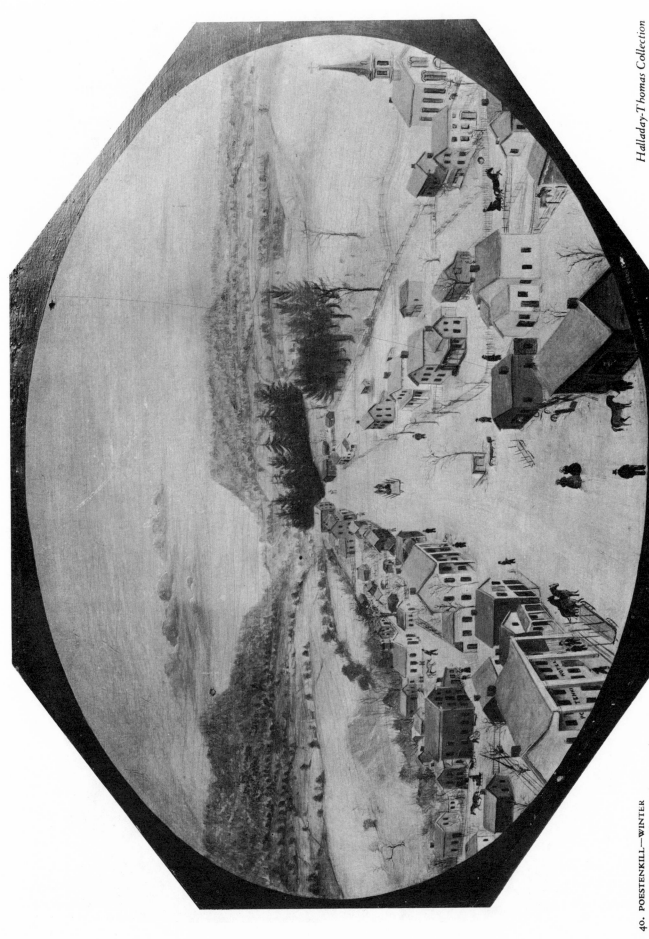

40. POESTENKILL—WINTER Joseph H. Headley Oil on wood c.1850

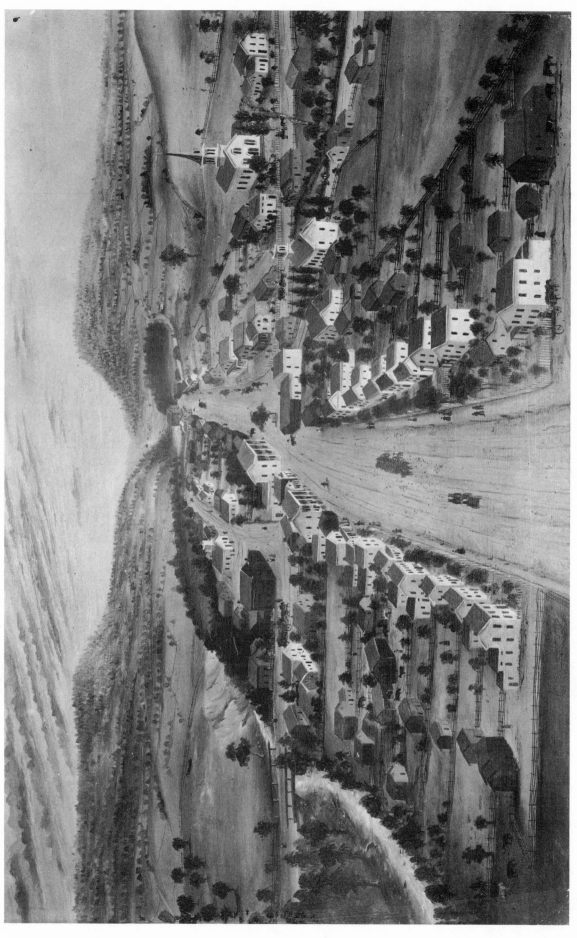

41. POESTENKILL—SUMMER

Joseph H. Headley Oil on wood c.1850

Halladay-Thomas Collection

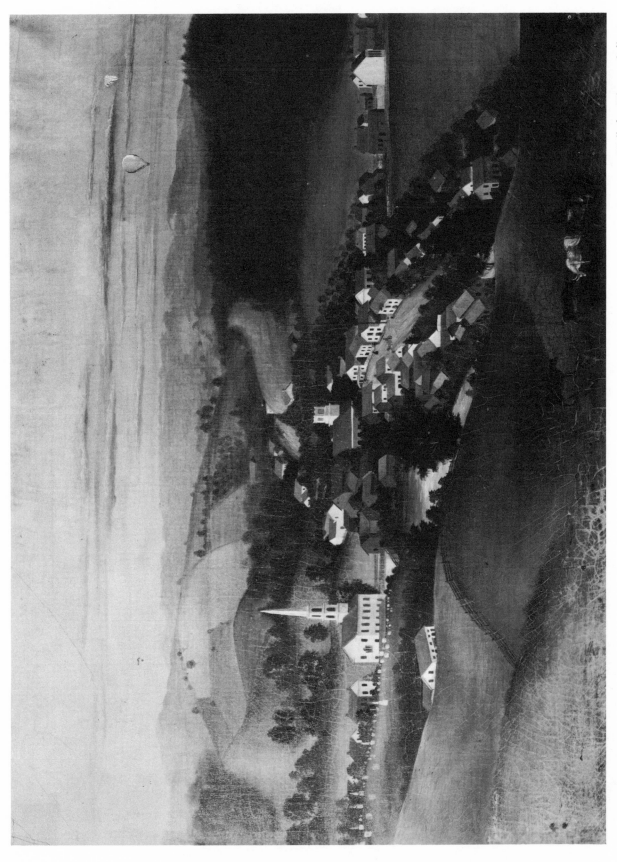

Halladay-Thomas Collection

42. WEST SAND LAKE Joseph H. Headley Oil on canvas c.1850

43. **RUNAWAY HORSE**
Oil on canvas c.1850

Whitney Museum of American Art

44. 'THE PROPERTY OF THE HON. E. S. DOUGHTY—NEW HUDSON, N. Y.'
J. S. Jennings Oil on canvas 1853

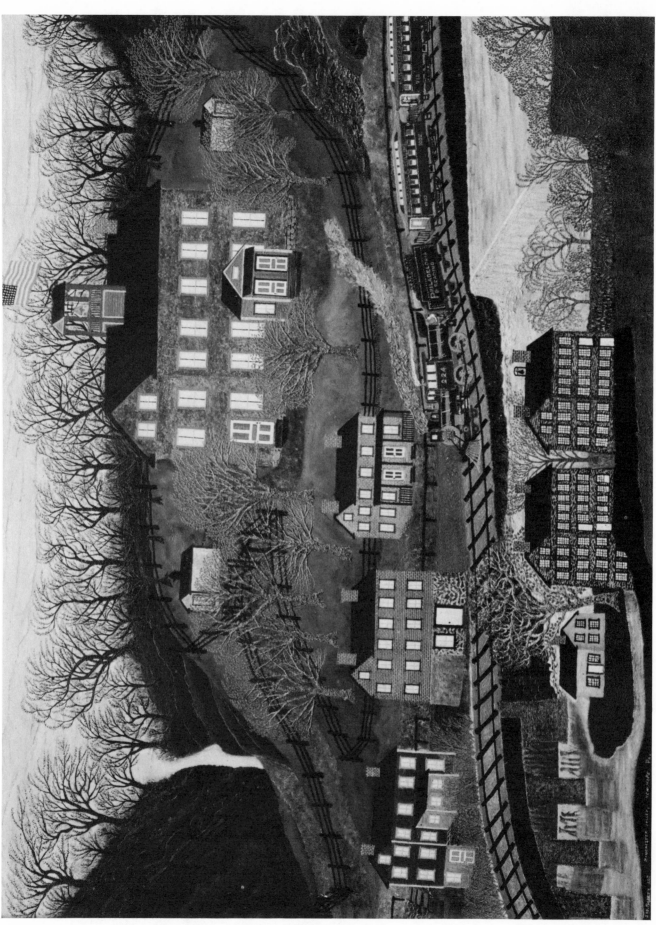

45. MANCHESTER VALLEY
Joseph Pickett Oil on canvas 1914-18(?)

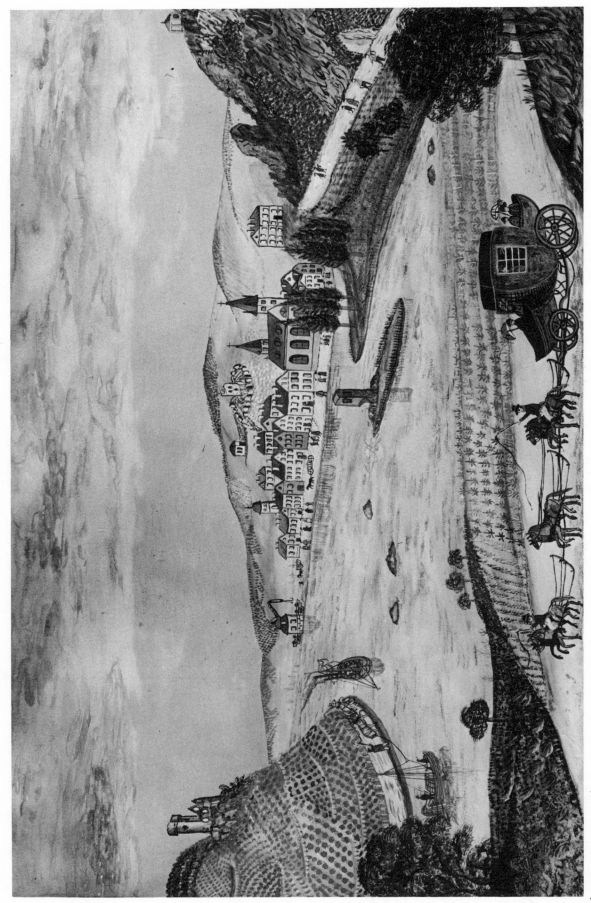

46. 'ANSICHT VON BINGEN' c.1830
Pennsylvania watercolor

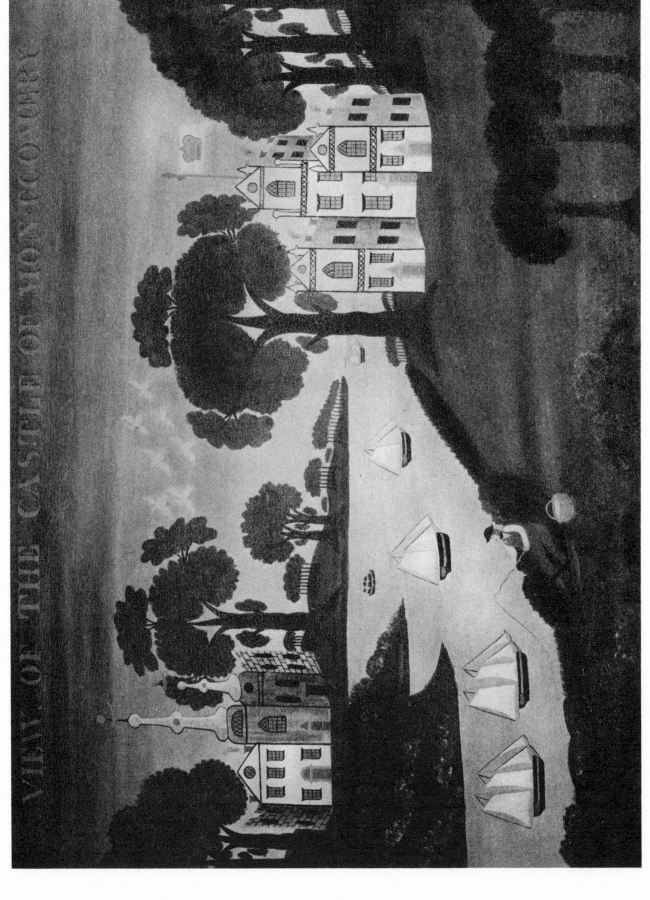

47. 'VIEW OF THE CASTLE OF MONTGOMERY'
Oil on canvas Early 19th century

Horace W. Davis Collection
Courtesy, New York State Historical Association, Cooperstown

48. WINTER SUNDAY IN NORWAY, MAINE
Oil on canvas c.1870

Collection of the author
Courtesy, New York State Historical Association, Cooperstown

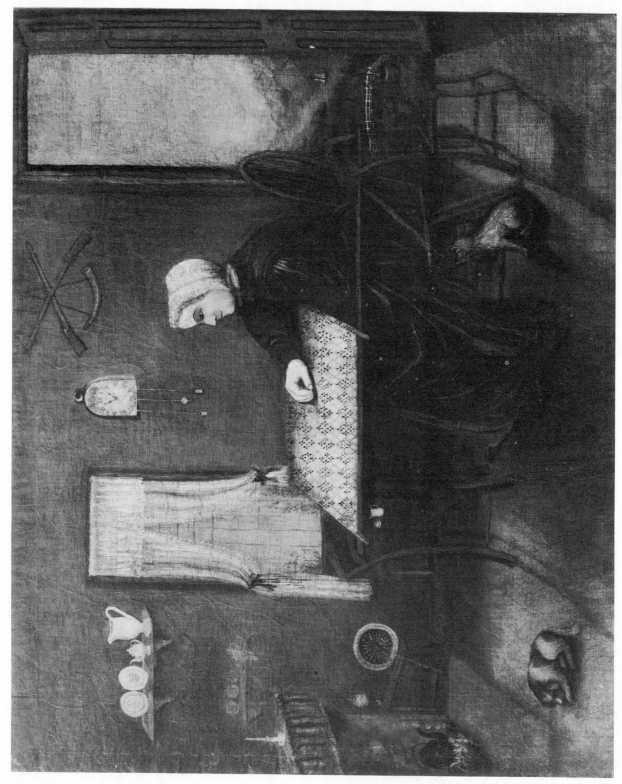

American Folk Art Gallery, New York

49. AT THE LOOM c.1795
Oil on canvas

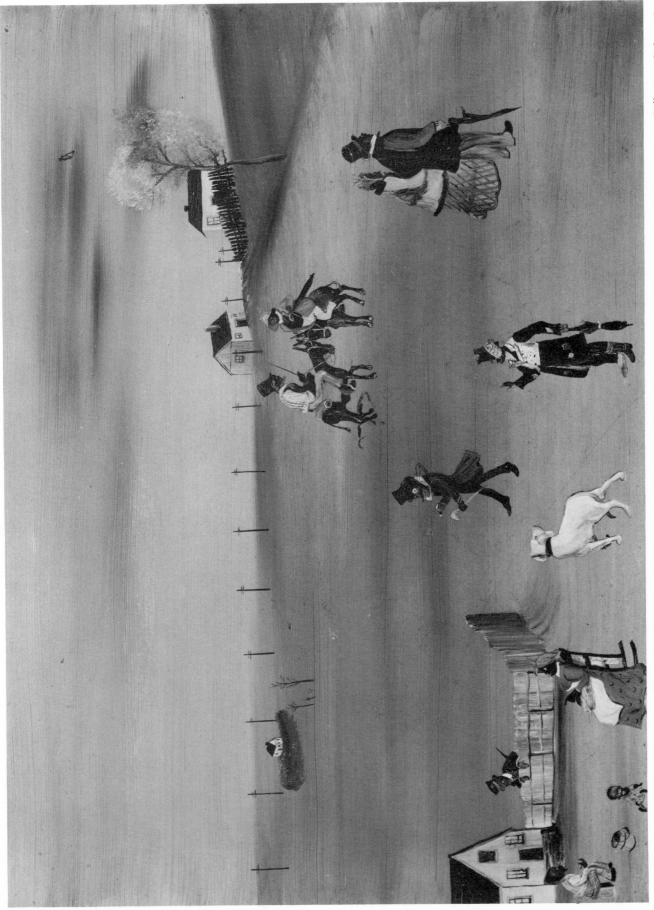

50. DARKYTOWN c.1860
Oil on glass

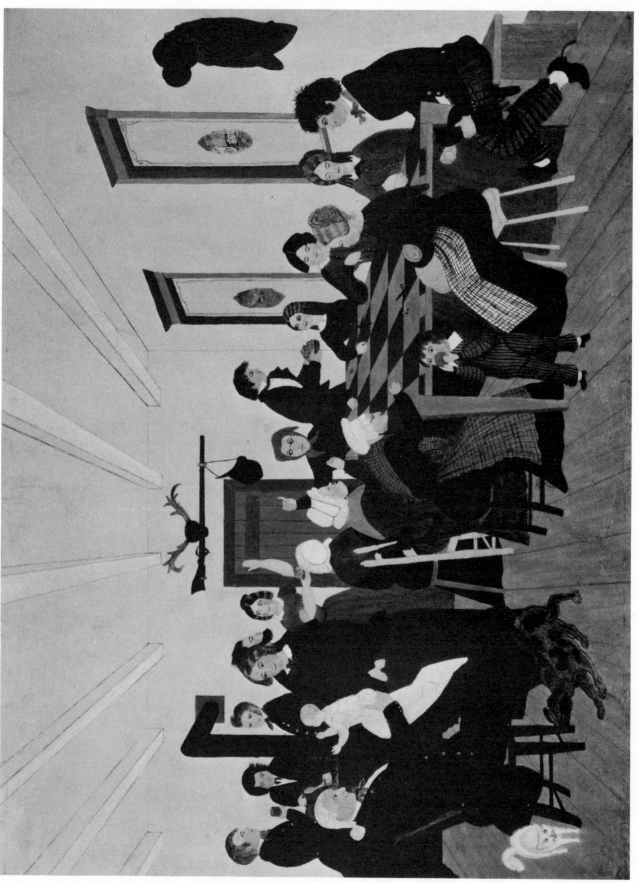

51. THE QUILTING PARTY 1840-50
Oil on wood

Museum of Modern Art
Courtesy, Rockefeller Collection, Williamsburg

52. FLAX SCUTCHING

Linton Park Oil on canvas 1850

Harry Stone, New York

Courtesy, William and Bernice Garbisch Collection, National Gallery of Art

53. YORK SPRINGS GRAVEYARD 1850-60
R. Fibich Oil on canvas

Collection of the author

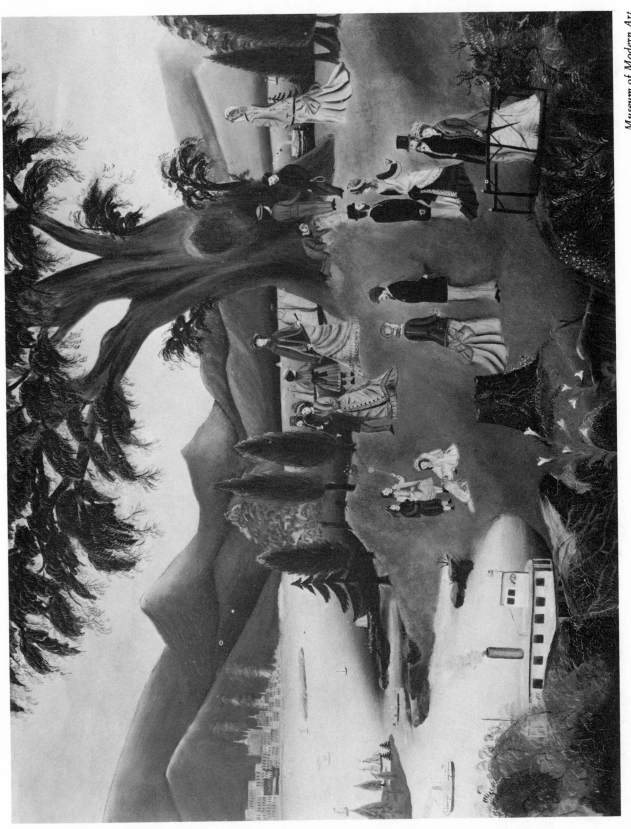

54. HUDSON RIVER SCENE c.1870

Oil on cardboard

55. WINTER IN THE COUNTRY
Watercolor c.1830

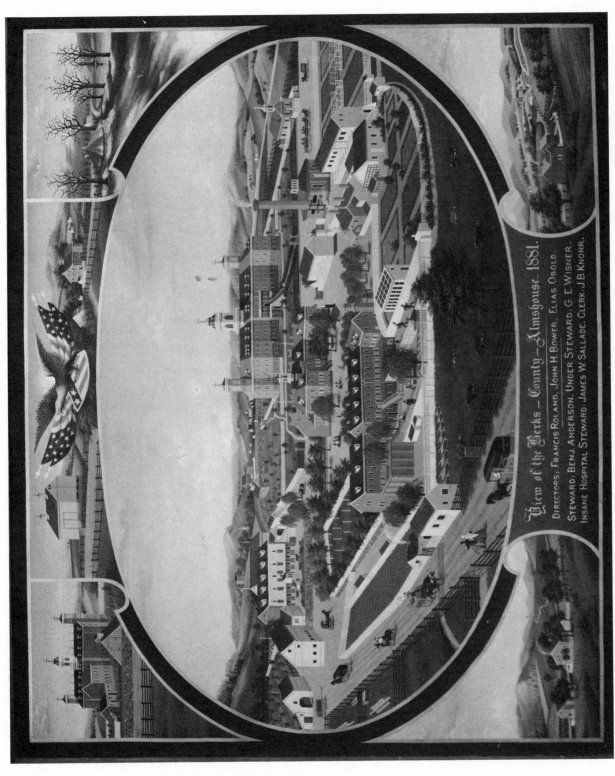

56. 'VIEW OF THE BERKS-COUNTY-ALMHOUSE. 1881.'
J. Rasmussen Oil on zinc

57. 'THE RESIDENCE OF DAVID TWINING IN 1787'
Edward Hicks Oil on canvas Early 19th century

Museum of Modern Art
Courtesy, Rockefeller Collection, Williamsburg

58. FARM SCENE Mid 19th century
Watercolor

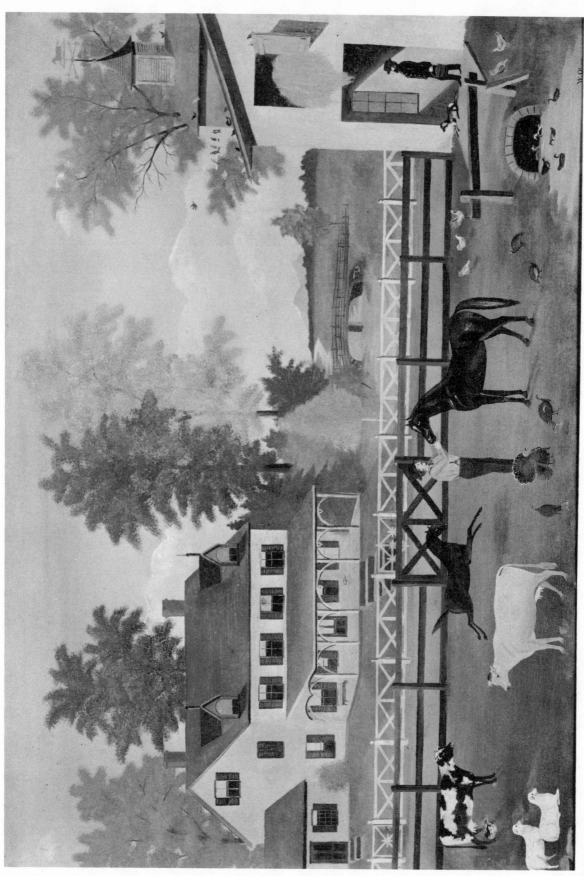

59. FARM SCENE Oil on canvas c.1875

W. Oliver Old Print Shop, New York

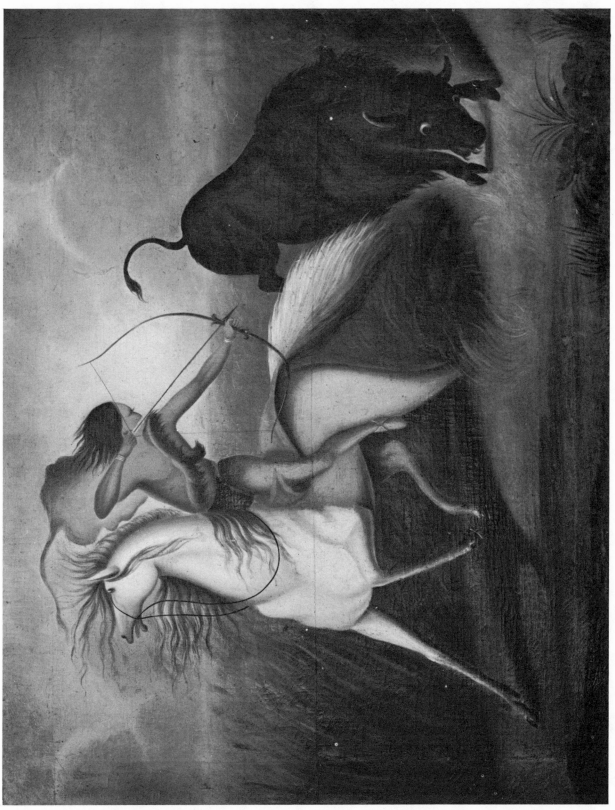

60. BUFFALO HUNTERS Oil on canvas Mid 19th century

61. CHARLESTON PRISON
Watercolor Mid 19th century

62. CLEVELAND PUBLIC SQUARE
C. M. Giddings Oil on canvas 1839

Western Reserve Historical Society

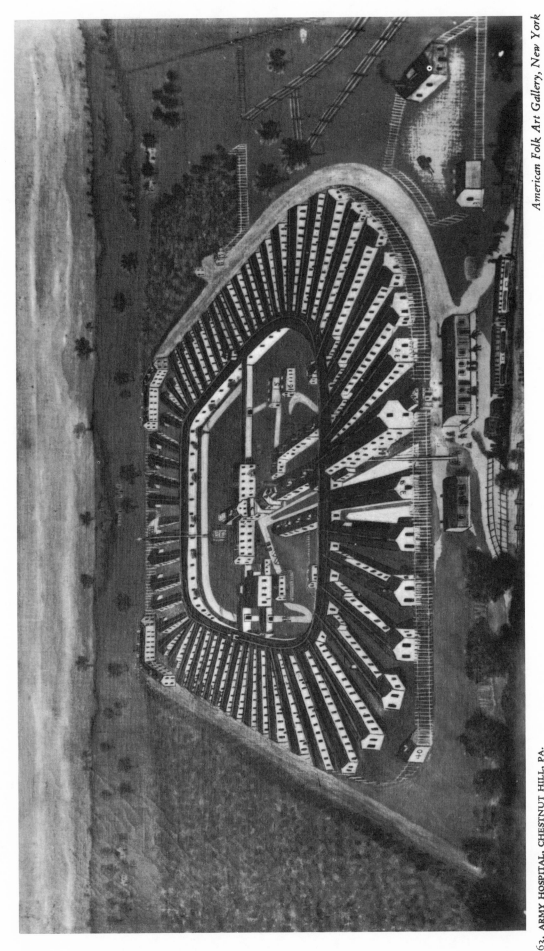

63. ARMY HOSPITAL, CHESTNUT HILL, PA.

Oil on canvas c.1865

64. 'THE FIRST TRANSCONTINENTAL TRAIN LEAVING
SACRAMENTO, CAL. IN MAY 1869'
Joseph Becker Oil on canvas

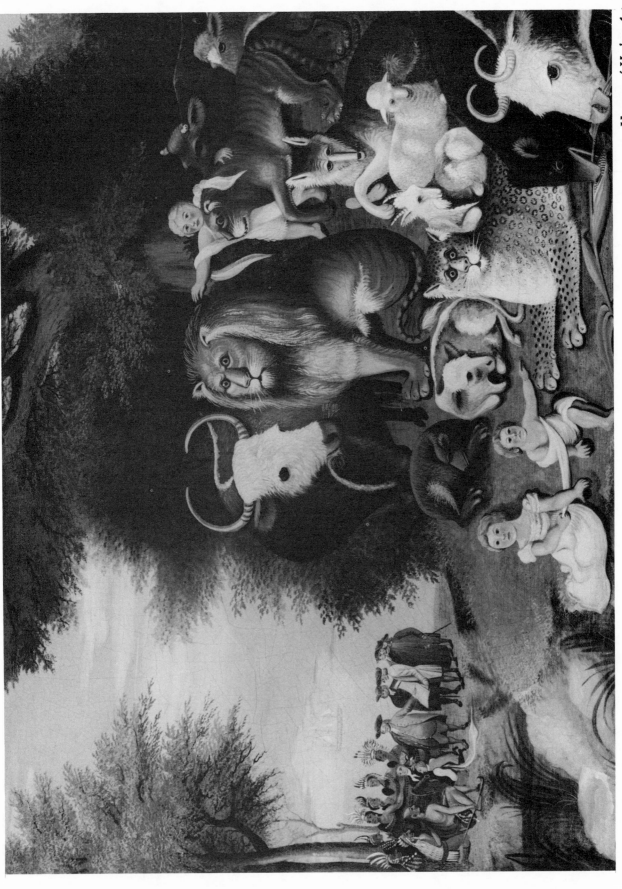

65. THE PEACEABLE KINGDOM c.1835

Edward Hicks Oil on canvas c.1835

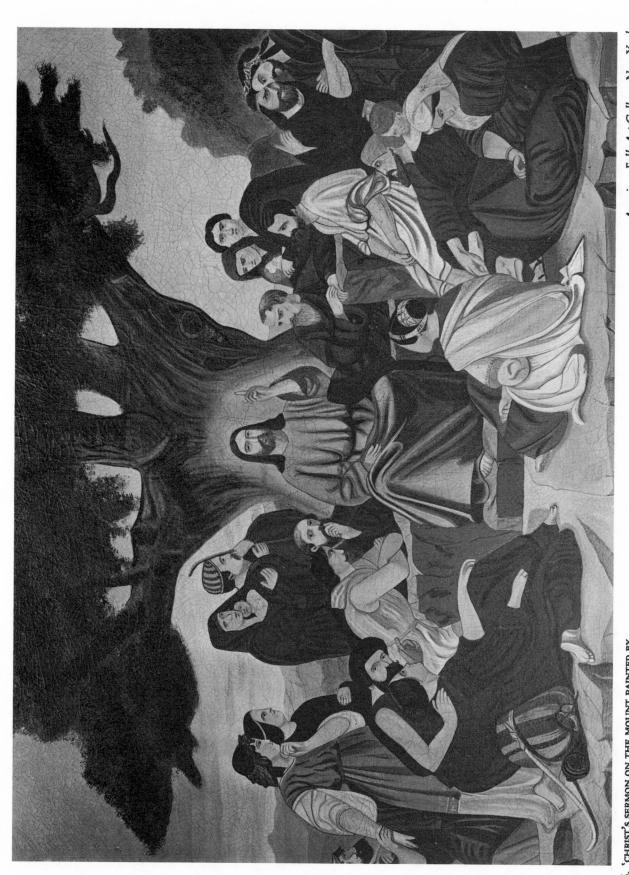

66. 'CHRIST'S SERMON ON THE MOUNT PAINTED BY
PLATTENBERGER'
Oil on canvas Mid 19th century

American Folk Art Gallery, New York

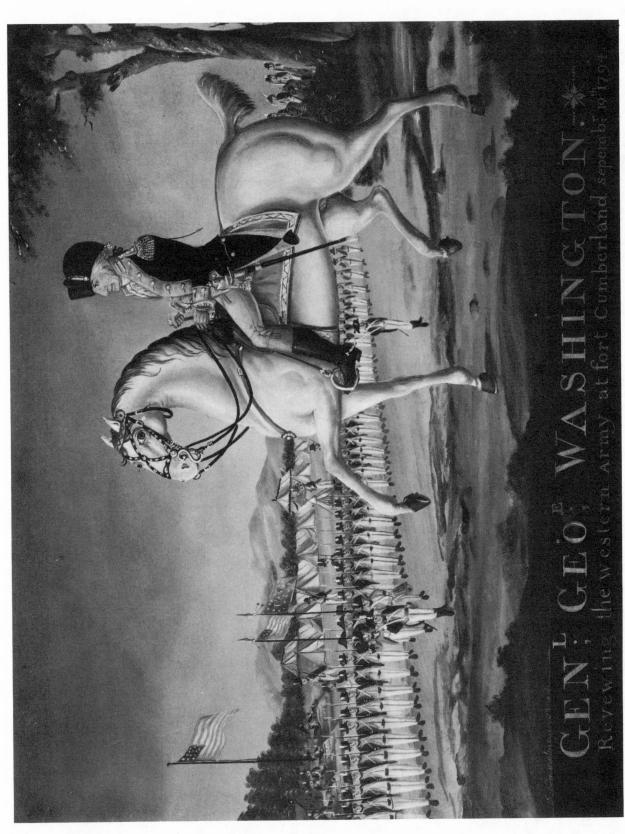

67. 'GENERAL GEORGE WASHINGTON REVIEWING THE WESTERN
ARMY AT FORT CUMBERLAND SEPTEMBER 19th, 1794'
A. Kemmelmeyer Oil on canvas

Bland Gallery, New York

68. WASHINGTON UNDER THE COUNCIL TREE

Joseph Pickett Oil on canvas 1914-18(?)

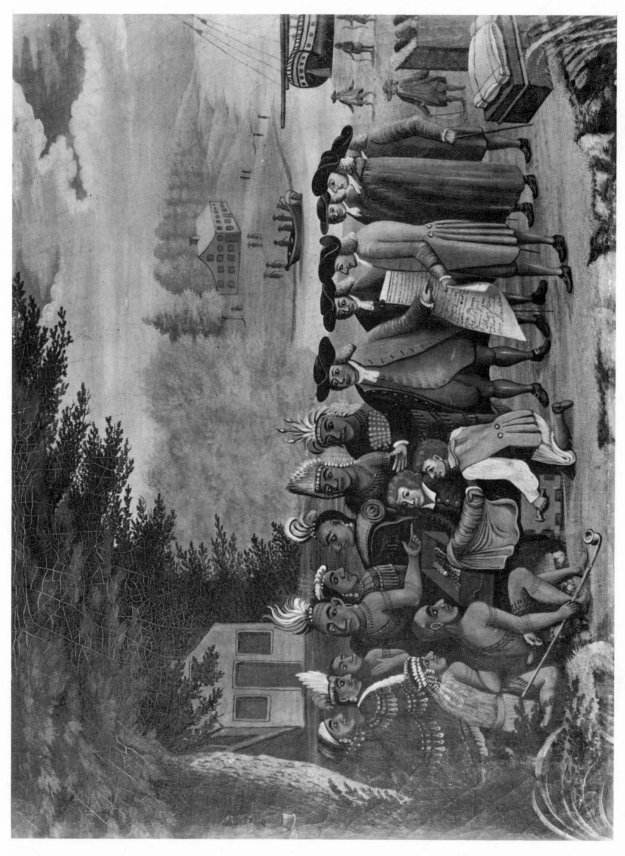

69. PENN'S TREATY WITH THE INDIANS c.1830
Edward Hicks Oil on canvas

70. BATTLE OF GETTYSBURG c.1865
Oil on canvas

Walter P. Chrysler, Jr. Collection

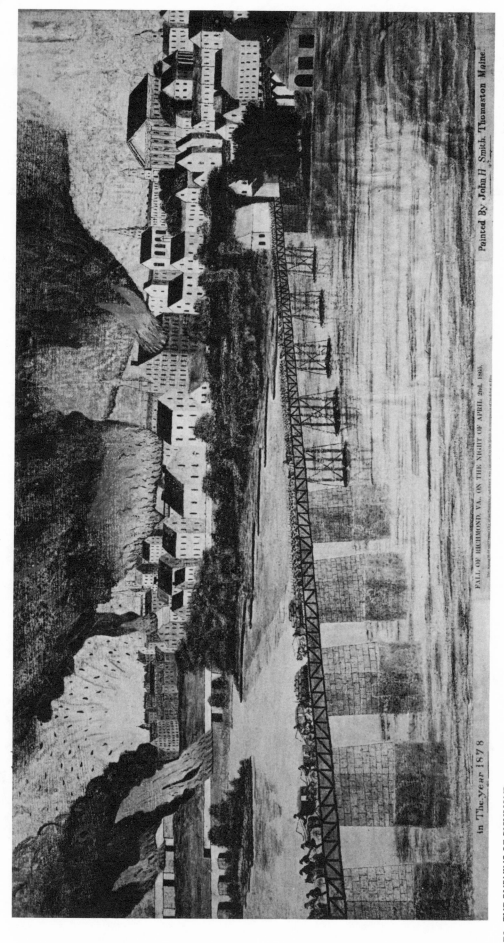

In The year 1878

FALL OF RICHMOND, VA., ON THE NIGHT OF APRIL 2nd, 1865.

Painted By John H. Smith. Thomaston Maine.

Marguerite Zorach Collection

71. THE BURNING OF RICHMOND
John H. Smith Watercolor 1878

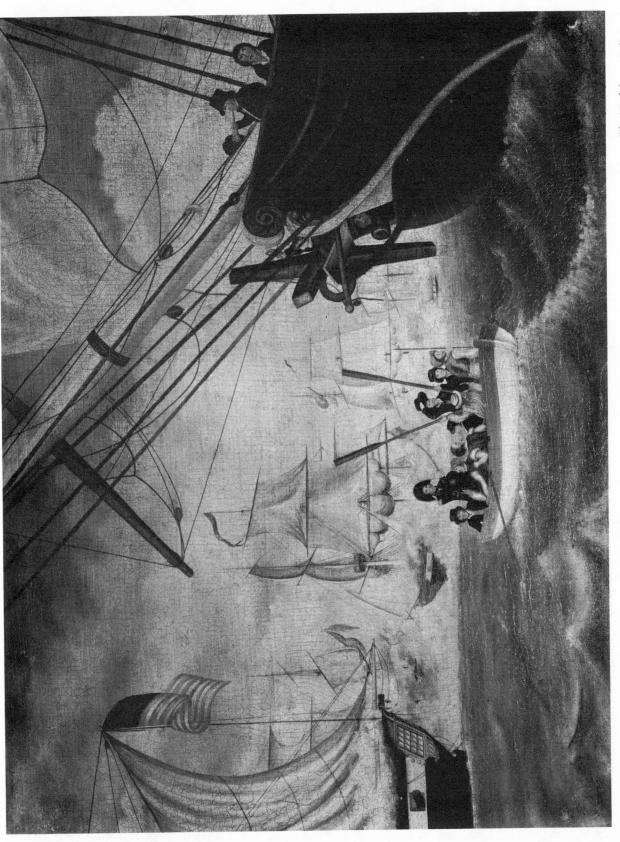

Elie Nadelman Collection

72. **THE BATTLE OF LAKE ERIE**
Oil on canvas Early 19th century

73. OUTWARD BOUND c.1860
Oil on canvas

Courtesy Horace W. Davis Collection

74. **YANKEE CLIPPER** Mid 19th century
Oil on canvas

Walter P. Chrysler, Jr. Collection

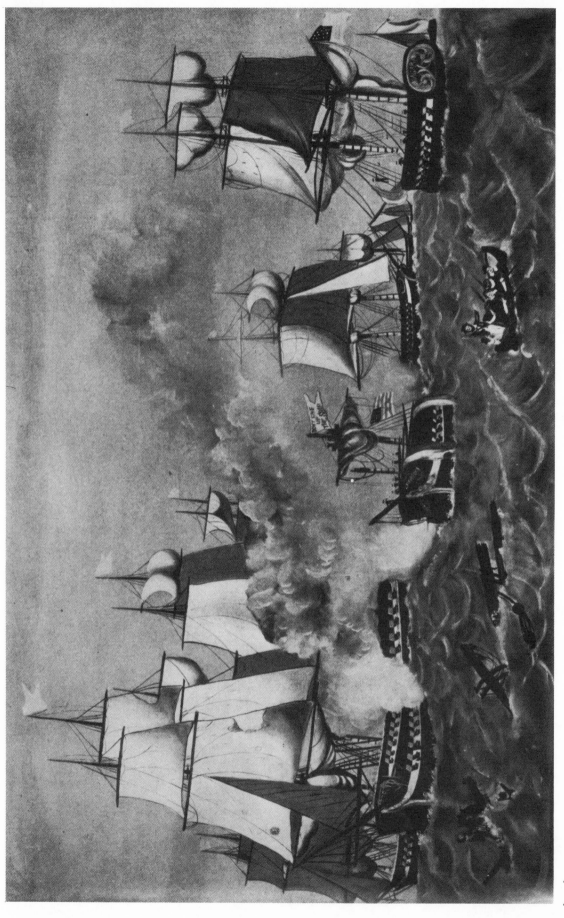

75. 'DON'T GIVE UP THE SHIP' Early 19th century
Oil on canvas

A Lady's Painting Portfolio

PAINTING in watercolor was part of the curriculum of the female seminaries in the nineteenth century, and was diligently studied by cultivated young ladies and accomplished housewives. This accounts for the large group of watercolor paintings which add a feminine touch to collections of folk art. Some few of these talented female amateurs seem also to have turned discreetly professional, executing at home decorative pieces and memorials in the same way that others worked and occasionally sold bits of fine embroidery. One such lady-watercolorist of extraordinary talent was Eunice Pinney, who was born in Simsbury, Connecticut, in 1770, and lived and worked in Windsor in the first decades of the nineteenth century. A portfolio containing dozens of her watercolor scenes and memorials was found some years ago. Several of these watercolors are reproduced in the plates which follow. Ladies' paintings such as these, usually executed on paper or velvet, comprise a variety of types: portraits, landscapes, religious, historical, and literary scenes, memorials, 'fancy' pictures, and, most numerous, the flower and fruit still-life pieces.

The abstract stylized character of these American Primitive watercolors is immediately apparent. Rather than being spontaneously executed from real models they were meticulously constructed bit by bit according to specific rules. The still-life groups were frequently done from prints and were executed by means of stencils. The landscapes were imagined more often than seen, their subjects inspired

by literature rather than life; and many of them were so conventionalized as specifically to suggest embroidery designs in long-and-short, cross-stitch or cruelwork. The memorial pictures were of formalized design and contained certain standard props, such as the tomb, mourners at the grave, weeping willow, and mourning dove; and often included a trumpeting angel in the sky and a house or town below, symbolic of the heavenly as opposed to the earthly home. It is worth remarking that some Primitives, such as the typical memorials, are entirely conventionalized, while others display boldly original design and content (see Plate 85). These seeming extremes have a common denominator—a radical departure from visible reality.

The execution of these paintings was anything but a casual affair. The young ladies were expected to devote to them the same painstaking effort that they bestowed upon their fine needlework. The designs for the still-life paintings had to be drawn, traced, and applied to the paper or cloth, the required stencils or 'theorems' must be cut out of specially prepared oiled paper, the paints had to be ground, mixed, and accurately applied according to directions.

The material illustrated in Plates 76 and 77 and the letter of instructions and set of 'recipes' quoted below were found in Lucy McFarland Sherman's painting portfolio, assembled by her in Peekskill, New York, in the mid-nineteenth century. This typical portfolio—there is another much like it in the Horace W. Davis collection—contains study notes, color samples and practice sheets, colored prints for use as models, a large number of stencils, many detailed tracings with full color notes, oiled paper, tracing paper, drawing paper, and watercolor paintings in all stages of completion.

It seems worth publishing this kind of source material, which gives as nothing else can a first-hand idea of the intellectual non-visual approach to painting which characterizes all types of American Primitive painting. It is this approach which entirely accounts for the striking qualities of design which have made the Primitives so popular with twentieth-century collectors who value abstract art in all its manifestations, and with the sophisticated twentieth century painters who

consciously aim at the abstraction which the naïve provincial painters unconsciously achieved.

<div align="right">

175 West 48*th* St.
New York
Jan'y 20*th* 1850.

</div>

My dear Mrs. Sherman

I found your kind note when I returned. . . . I generally give extra lessons in fruits. But if you have practiced as I hope you have I can give you *written* instructions on *fruit* or *flowers*. My copies would be too expensive. I am realizing from 7 to 15 $ for my watercoloured groups. I have obtained the accompanying ones which are lovely 9/- each, and will explain them in every part. You must shade *just* as the *engraver* had shaded, let your lights fall where his fall in every instant throughout the pieces. Miss Whitney no doubt would buy your designs when you have done or reserve them for your pupils by and by. . . .

No. 8—Flowers—your lines you paint in every variety of greens—laid in *very thin* indeed.

2 roses—as square No. 7—and deepen to your taste.

Rose No. 3. Like square No. 4. Lay in thin yellow all over, then cut a centre out, and dash in 1 section at a time carmine mixed with wood brown, then put in your dots with deep yellow.

Jasmine No. 5. You draw every line distinctly—then cut the depths between every leaf first, and shade with intense shading. Then draw them again and each Jasmine leaf you give a very slight shade of pink with dry rose brush. Put in the star centre green with small brush.

Narcissus No. 6. Lay in thin pale yellow. Shade intense shading.

Concerning No. 7—pale yellow mixed with white, shaded with autumnal tint. Green stem to contrast, between flowers. Calix also Chinese green shaded with brilliant green.

Butterfly No. 8—pale blue. Shade with purple.

Fruit No. 13—first slab No. 1, intense shading. Leaf No. 2. Lay in Naples green, shade wood brown, and dot edges with Lake carmine, rim sepia. Stems green shade w. brown. Leaf No. 4 Naples green, shade autumnal tint then blue and green. Leaf No. 5—same. Leaf No. 6—Green mixed yellow—shade brown & green. No. 7 brown-green shade.

Grapes No. 8—first draw every line correctly then begin at the last one. Then every dark part first, then proceed, one after other with shaded green then a little autumnal tint, then a little lake for every one. More depth in the darker parts.

<div align="center">

(99)

</div>

No. 9 Apricot—pale yellow mixed with a little *orange*, then shade carmine & in the deep parts to brown.

Orange No. 10. Lay in with orange mixed with yellow—*a little,* then shade orange then autumnal tint in the depths. When done, take the piece outline paper you have taken from your orange—brush over it. This makes those small impressions you see in an orange.

Stem No. 11. Begin with sub green. Shade with brown, then black—in depths.

Butterfly No. 12. Orange, shaded brown.

Wine glass—No. 13. Shade wine first vermillion & carmine. Mix in then brown. Cut every point separately. Make lights on your glass with india rubber.

The turning in leaf No. 1 is false—do it as your book directs.

Excuse this scribble, . . .

RECIPES

To Grind your Color

Pour a little on your Palette, & wet with a few drops of water & 2 drops of your preparation; then grind with your palette knife until it is as smooth as oil. If you require more liquid, 1 drop of gum arabic water.

Tracing Paper

Take 1 sheet of tissue paper, & grease it on one side with sweet oil. Place the greased sheet between two others & iron with a warm iron. When it becomes transparent, hang it in a room where is no fire & in a few days it will be fit for use.

To Paint on Wood

Have your panel prepared in some desirable shape of ash or holly by a good cabinet maker & make very smooth and before you commence painting wash with thin gum to prevent your color running. When finished varnish with gum water. When you have finished every part of your painting, proceed to give a coat of White Mastic or white copal varnish, laid on with a badger or camel's hair brush. Allow each coat to dry before you put on another.

To Paint on Silk or Satin

Fix your piece of silk on your drawing board or any fine surface, with drawing pins. If the silk be white, you proceed as on paper: if dark or coloured, lay in your shade or grounds oftener, as on wood, & when finished use a little thin gum water to fix them firmly.

Painting on Cloth

Fix your piece of cloth before you mark out the shape with chalk. Prepare your design, leaves on one piece of paper & flowers on another. On cloth you must lay in your color *often* before you can destroy the rough surface, then shade as on paper only heavier. When all is finished, varnish carefully with white copal, & the colours never fade, but look like the finest embroidery. Do not take your work from the drawing board till perfectly dry.

To make Transparent Paper

Take 10 oz. of white rosin to 1 qt. Spirits Turpentine & 1 table spoon of boiled oil. When dissolved by slow heat, cut *book printing paper* to the size you may wish it—lay it in a dish or Tea tray—varnish over with a sponge on both sides. Hold it to the fire—not too near, for a short time & then repeat it twice. Pin it to a cord in some room you do not use. This paper is used for outlining your flowers or designs.

LADIES' WORK

DECORATIVE PIECES

MEMORIALS

PORTRAITS

SCENES

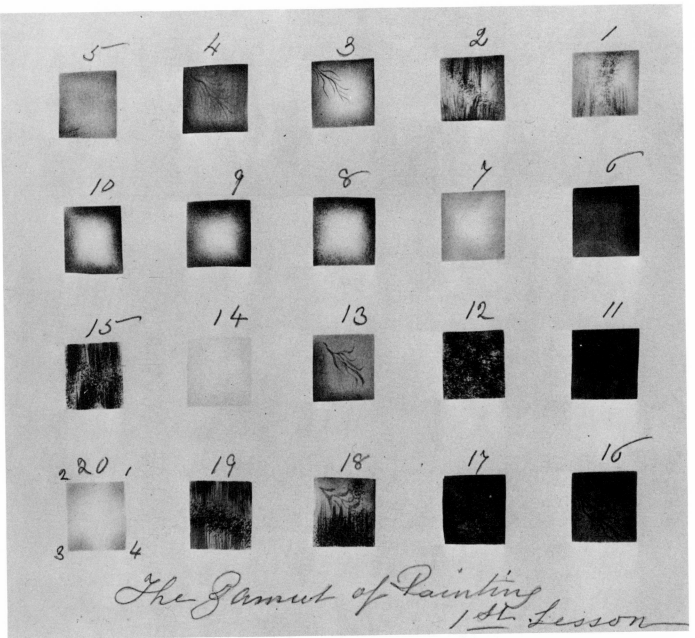

76. 'THE GAMUT OF PAINTING IST LESSON'
Lucy McFarland Sherman c.1850

Julia Munson Sherman Collection

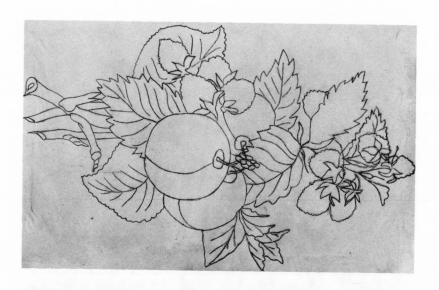

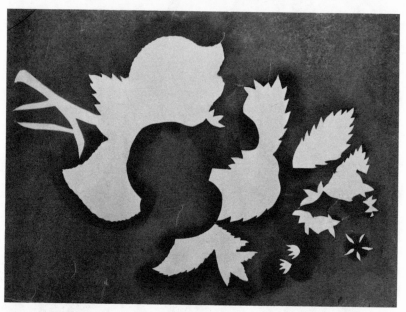

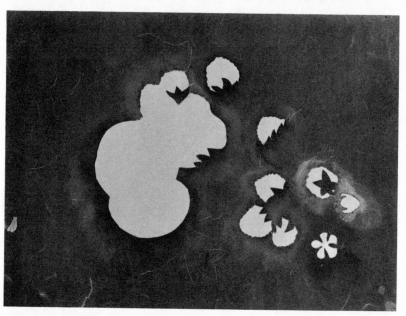

77. DESIGN AND STENCILS FOR A THEOREM PAINTING *Julia Munson Sherman Collection*
Lucy McFarland Sherman 1850-60

78. **FRUIT IN BLUE BOWL**
Watercolor Mid 19th century

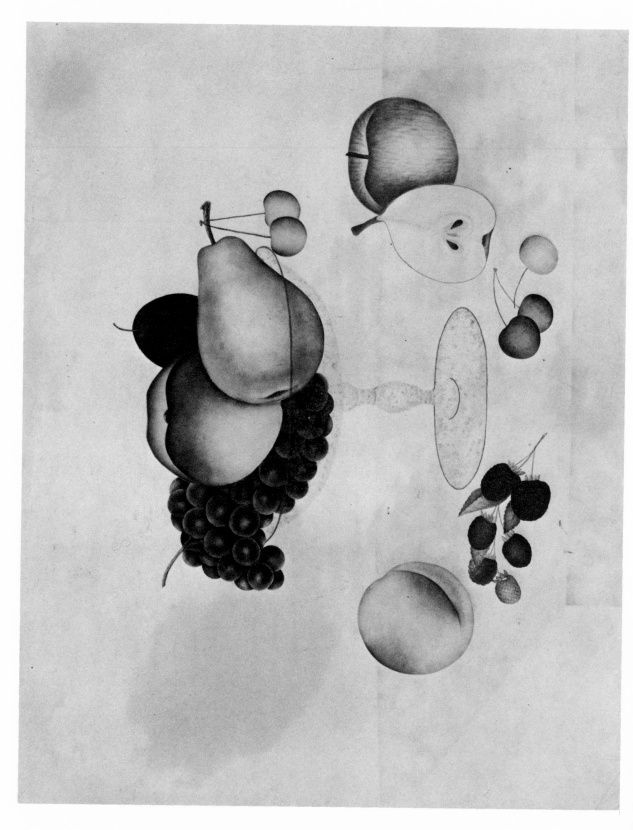

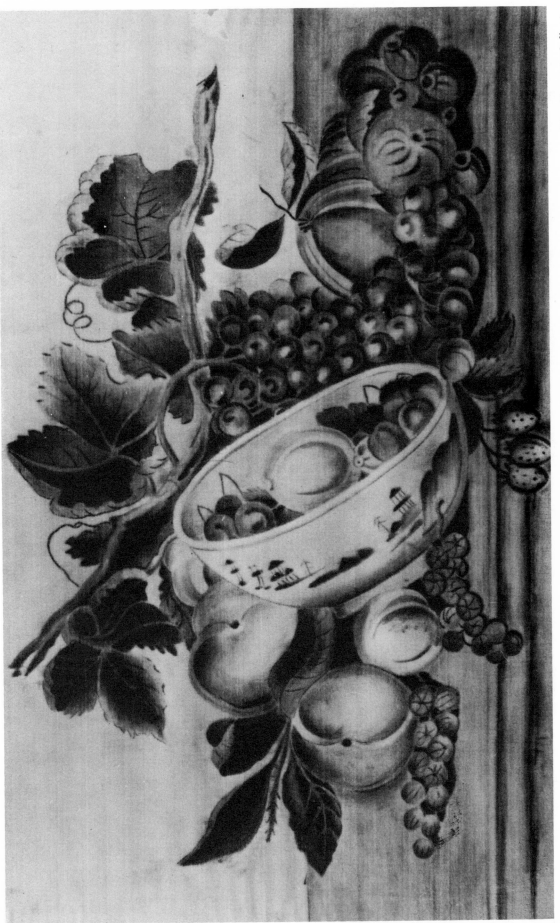

Aline Bernstein Collection

80. STILL LIFE Velvet painting Early 19th century

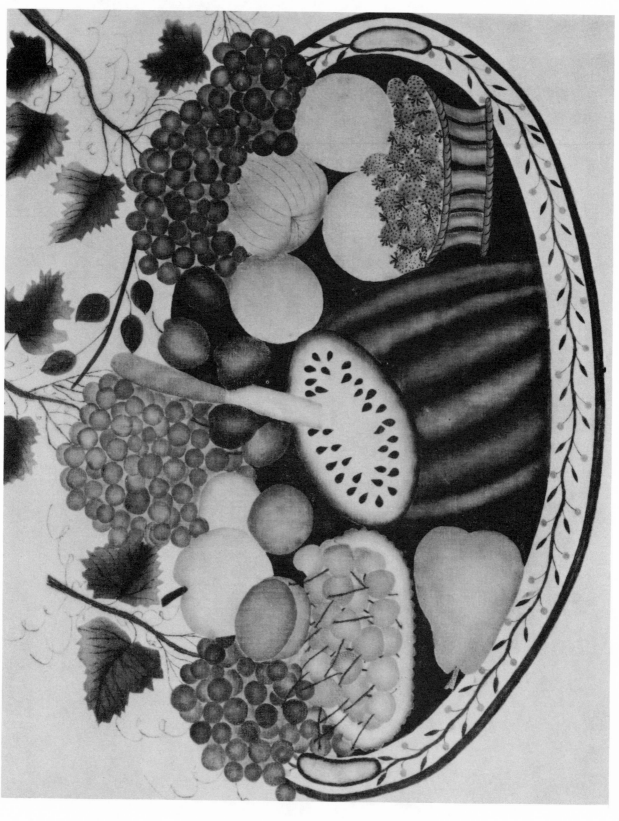

81. **FRUIT ON A PLATTER**
Velvet painting Early 19th century

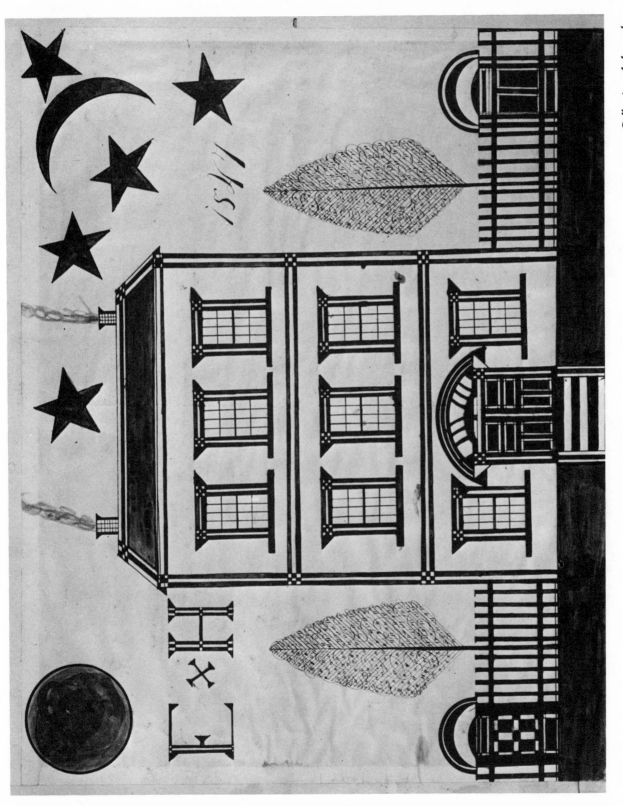

82. BLUE HOUSE
Steel pen drawing and watercolor 1841

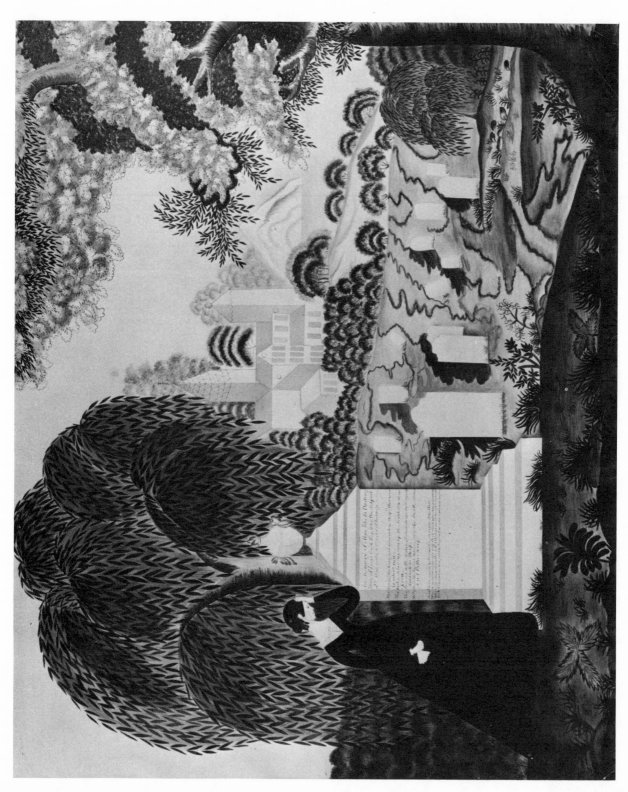

83. MEMORIAL FOR MRS. RHODA DARLING 1843
Black-and-white watercolor

Aline Bernstein Collection

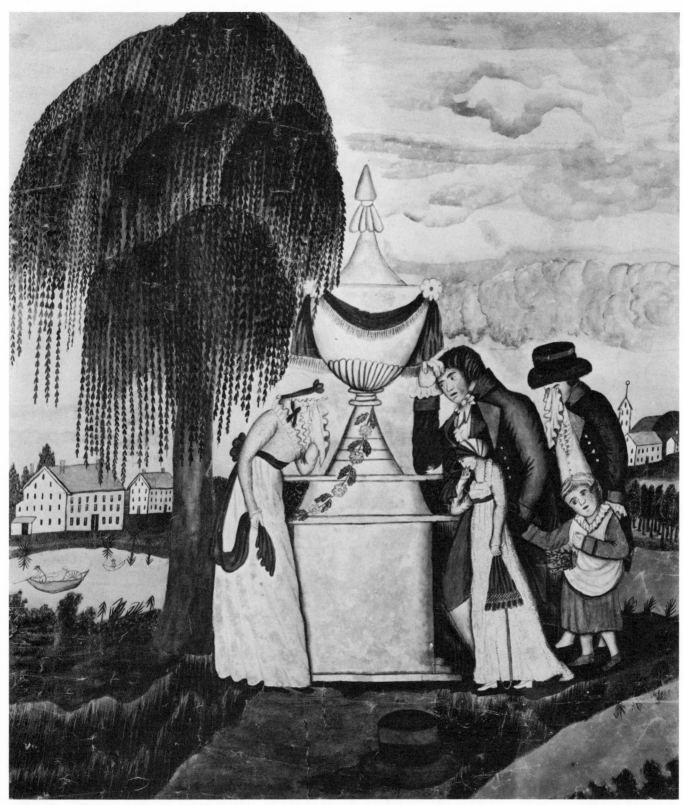

84. MEMORIAL
Eunice Pinney Watercolor c.1815

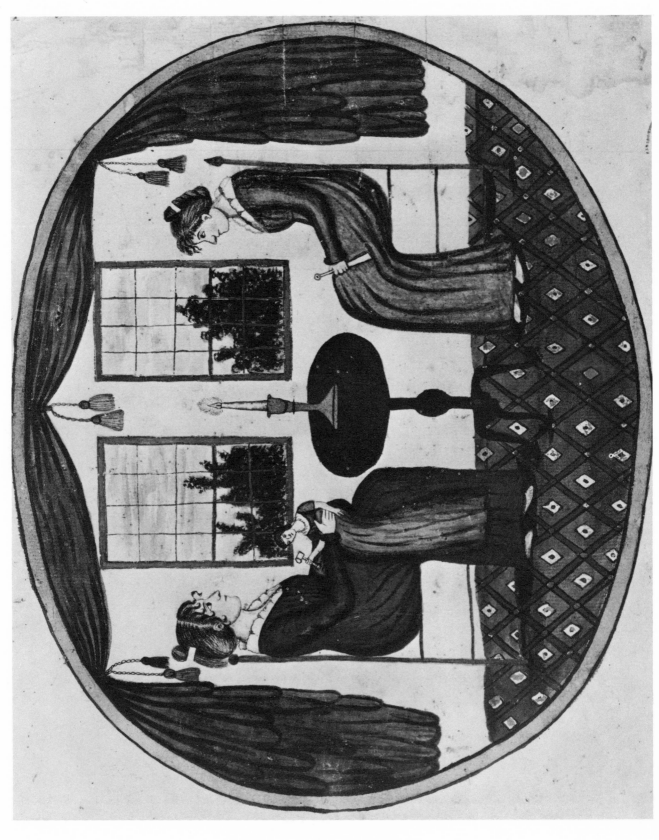

85. TWO WOMEN
Eunice Pinney Watercolor c.1815

86. LOVE AND WAR
Eunice Pinney Watercolor c.1815

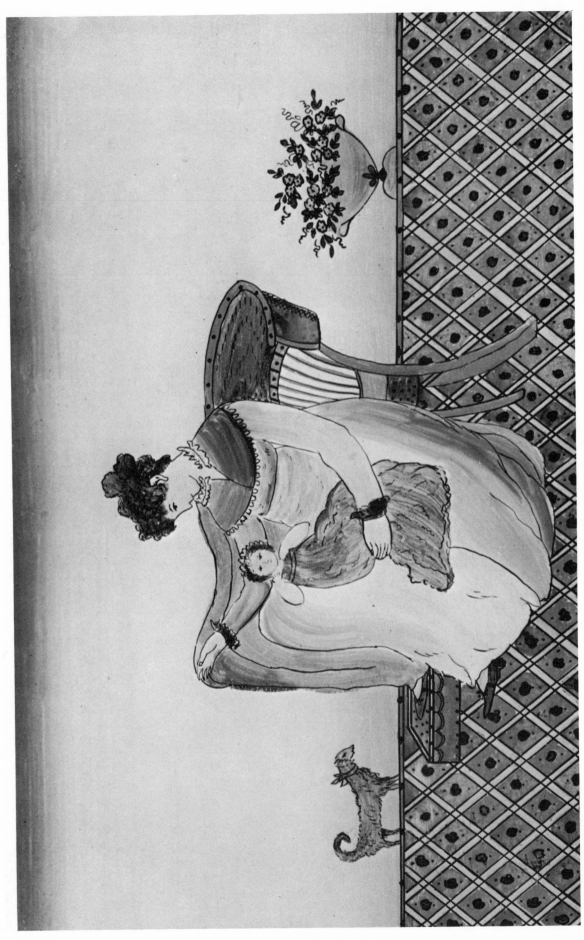

87. NEW ENGLAND GLASS PAINTING
c. 1810-20

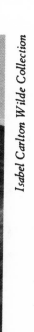

88. NEW HAMPSHIRE SISTERS Emily Eastman Louden Watercolor c.1820

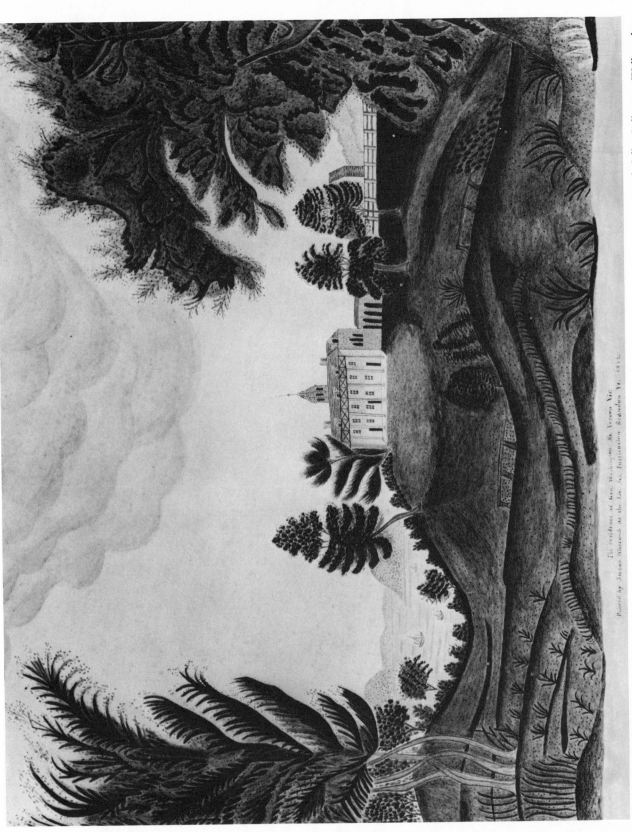

Rockefeller Collection, Williamsburg

89. 'THE RESIDENCE OF GEN. WASHINGTON MT. VERNON VIR.
PAINTED BY SUSAN WHITCOMB AT THE LIT. SCI. INSTITUTION, BRANDON, VT. 1842'
Watercolor

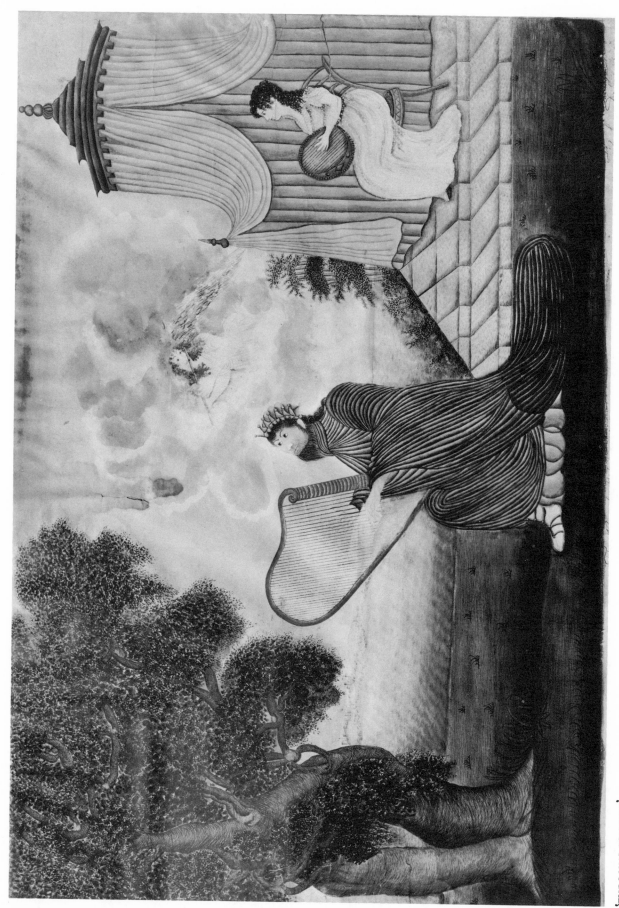

90. 'THE ROYAL PSALMIST'
Lucy Douglas Watercolor c.1810

American Folk Art Gallery, New York

91. COLGATE COLLEGE Watercolor Mid 19th century

Wall Decorations

LITTLE remains today to show for the labors of the old itinerant 'decorators' who traveled about our countryside adorning plaster and paneled walls with stenciled designs and painted scenes in exchange for bed and board and a bit of pay. Plaster is not durable, and paneling is apt to be painted over many times within a hundred years. Fortunately some of these primitive wall paintings have been preserved. They are interesting not only as isolated examples of American Primitive painting, but also because they help us to reconstruct the richly decorative and colorful appearance of the typical early American interior.

To date there has been no general recognition of the striking fact that the early American home was gaily decorated inside and out—that roofs, clapboards, walls, floors, furniture, accessories, and draperies were brightly colored and patterned. The common colorless idea of 'Colonial,' artificially fostered by the ruthless refinishing and wholesale reproduction of antiques and interiors, has blinded us to the wealth of color and design which characterized the homes of our ancestors. We, in our white colonial homes, endure monotonous natural-pine floors, uniform maple-or-pine furniture, unrelieved white painted walls and paneling. But the old homestead was frequently painted Venetian red, russet, or yellow ochre; when white, the roof was often red, the trim blue or green; furniture was painted or stenciled; floors, woodwork, and sheathing were often painted pumpkin yellow, red, blue, or green; stencil motifs frequently adorned the gray, rose, or yellow

tinted walls; and walls and panels might be decorated with brisk landscapes and scenes such as those which are illustrated in the following plates.

The style of the primitive landscapes is well exemplified in these wall paintings, and the primitive painter's approach clearly evident.

Of prime interest in this connection is a series of articles on *Landscape Painting on Walls of Rooms* written by Rufus Porter, at one time an itinerant wall painter who in 1845 founded the *Scientific American* and was its first editor. These articles appeared in 1846 in volume I of the *Scientific American*. The author of this book, having arrived at a definition of the American Primitive painter's approach from a long and friendly acquaintance with primitive paintings, found it most exciting to see these conclusions verified in this naïve mid-nineteenth-century writing. Rufus Porter's articles are here presented in a series of excerpts as the most basic source material for any study of American Primitive painting.

The articles on wall painting are included in a series on *The Art of Painting*, intended to instruct the amateur in the practice of all branches of painting. It is significant that the directions for procedure are presented in the same practical spirit for portrait, miniature, watercolor, and landscape painting as for ornamental gilding and bronzing, ornamental painting on signs, carriages, and banners, and painting on cambric for screens and window shades.

In his introduction to the article on landscape painting, Porter announces that he will present the 'natural' as opposed to the dry academic approach to painting:

> We shall not, in this place, give the theoretic and systematic rules of perspective drawing, as usually taught in the schools, and which tends, invariably, to check, if not destroy a natural taste for drawing and painting; but arrange our instruction in such a manner that the learner will be amused with the task and encouraged to proceed.

The editor introduces his series of seven articles on *Landscape Painting on Walls of Rooms** with the remark that wall paintings are cheaper, more durable, and more elegant than paper hangings, and that if enough painters could learn this

*Compare the wood-cut illustrations for these articles with the examples of Porter's wall paintings reproduced on Plates 92 and 93.

(122)

quite simple art it would be widely used. He begins with instructions for mixing and applying the colors, and suggestions for laying out the design:

Make a *sky-blue* by adding celestial blue to whiting . . . also make a *horizon red* by mixing together ten parts in bulk of whiting with two of orange red and one of chrome yellow. Then make a *cloud color* by mixing an indefinite small quantity of horizon red with whiting. . . . The sky-blue may be applied by a large common paint brush, either new or worn; but a brush for the application of the cloud color should be large and short. . . . As a general rule, a water scene,—a view of the ocean or a lake,—should occupy some part of the walls. . . . Other parts, especially over a fire-place, will require more elevated scenes, high swells of land, with villages or prominent and elegant buildings. On the more obscure sections of the walls, especially such as are expected to be obscured by furniture, high mountains with cascades or farm-hills may be represented. Small spaces between the windows and the corners, may be generally occupied by trees and shrubbery rising from the foreground, and without much regard to the distance. . . .

Porter goes on to tell in detail how the design should be arranged and the colors such as 'stone-brown' and 'forest green' properly applied, with different types of colors and brush-strokes used for different varieties of trees. Then further practical instructions:

(123)

In painting the pictures of steamboats, ships, and other vessels, it is convenient to have a variety of outline drawings of vessels of various kinds, sizes and positions, on paper: the back sides of these papers are to be brushed over with dry venetian red; then by placing one of the papers against the wall, and tracing the outlines with a pointed piece of iron, bone, or wood, a copy thereof is transferred to the wall ready for coloring. The painting of houses, arbors, villages, &c., is greatly facilitated by means of stencils. . . . For this purpose several stencils must be made to match each other; for example, one piece may have the form of the front of a dwelling house . . . another the form of the end of the same house . . . a third cut to represent the roof; and a fourth may be perforated for the windows. Then, by placing these successively on the wall, and painting the ground through the aperture with a large brush . . . the appearance of a house is readily produced, in a nearly finished state. . . . Trees and hedge-fences . . . are formed by means of the flat bushing-brush. . . . This is dipped in the required color, and struck end-wise upon the wall, in a manner to produce . . . a cluster of small prints or spots thus:

Following these suggestions he proceeds to the less concrete problem of the painter's approach to his subject:

There can be no scenery found in the world which presents a more gay and lively appearance in a painting, than an American farm, on a swell of land, and with various colored fields well arranged. . . . In finishing up landscape scenery, it is neither necessary nor expedient, in all cases, to imitate nature. There are a great variety of beautiful designs, which are easily and quickly produced with the brush, and which excel nature itself in picturesque brilliancy, and richly embellish the work though not in perfect imitation of anything. This remark is particularly applicable to various wild shrubbery suitable for filling up the foreground, and usually based on the bottom of the first distance. . . . Of this variety we have presented a few samples at the head of this article. . . . Rough ledges of rock are often also applied to give variety to the first distance.

In two concluding articles the author considers the problem of how to acquire the art of designing landscapes:

This branch of painting admits of such an endless variety of designs, that it would be vain to attempt to give even a tolerable assortment for the use of the practitioner. . . . We have presented two or three slight outline sketches, however, at the head of this article and shall furnish a few more in our next. . . . Some of the most prominent objects and scenes which may be often re peated, though under different arrangements, are farms, fields, forests, farmhouses, palaces, arbors, wind-mills, observatories, villages, high rocks, ships, steamboats, sail-boats, islands, hunting scenes, carriages, cattle feeding or watering, children at play, military parades, water-falls, flower gardens, flocks of birds, balloons, canals, water-mills, railroads, bridges, &c. There must be a general consistency observed, and one scene made to connect with

another, even although the different scenes should represent different seasons of the year. . . . The learner, for the purpose of acquiring the art of designing, should habituate himself to making close observations of objects, and scenery, and to imagine various scenes in his mind, diverse from anything he has seen, and practice sketching such designs when his mind is most free from other cares.

WALL DECORATIONS
FRESCOES AND PAINTED PANELS

92. 'STEAMSHIP VICTORY'
Rufus Porter Fresco 1838

Colburn House, Westwood, Mass.

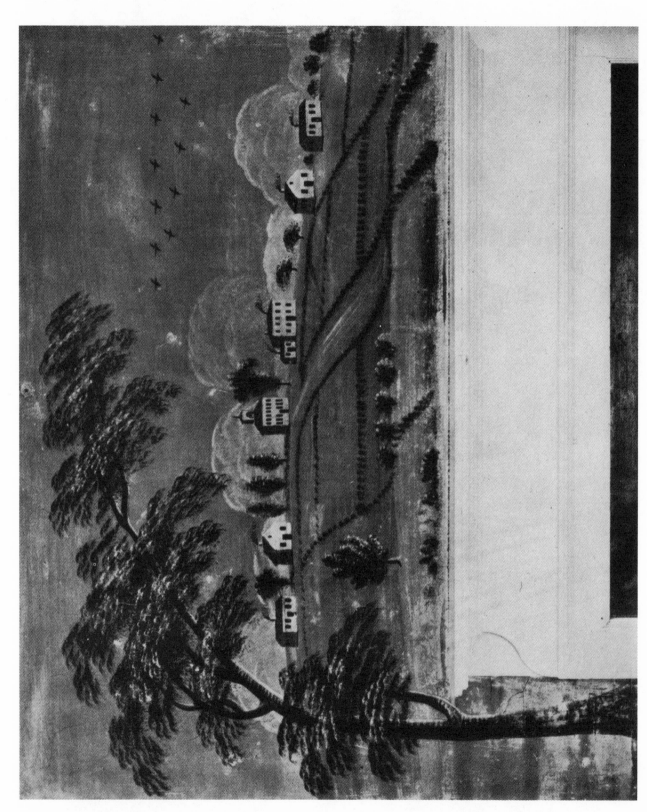

93. VIEW OF ANDOVER HILL *Van Heusen 17th Century Farms, N. Reading, Mass.*
Rufus Porter (?) c.1838

94. **HARBOR SCENE**
Fresco c.1818

Joshua Eaton House, Bradford, N.H.

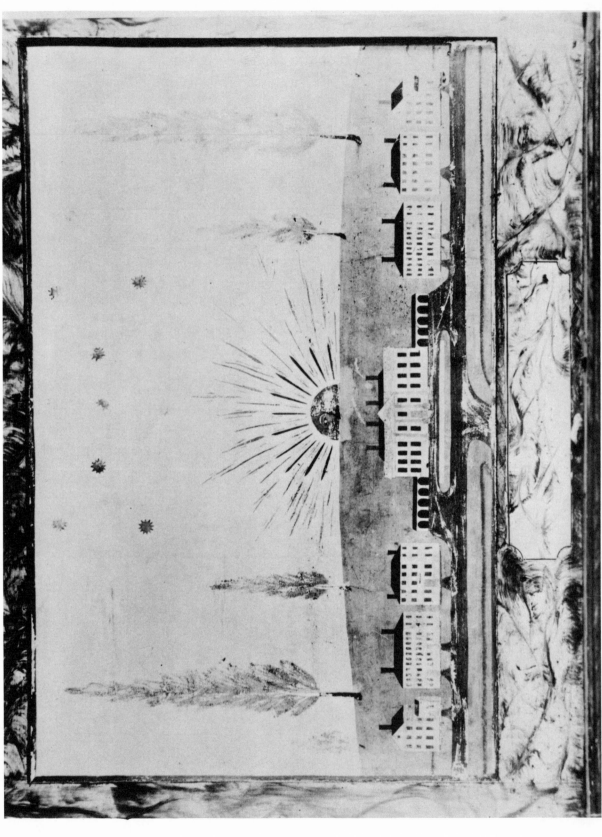

95. DARTMOUTH COLLEGE Overmantel fresco c.1815

Prescott Tavern, East Jaffrey, N.H.

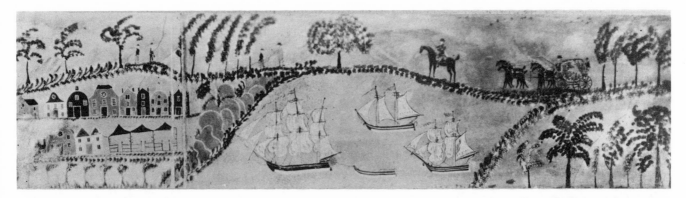

96. OVERMANTEL FRESCO

Ryther House, Bernardston, Mass.

c.1812

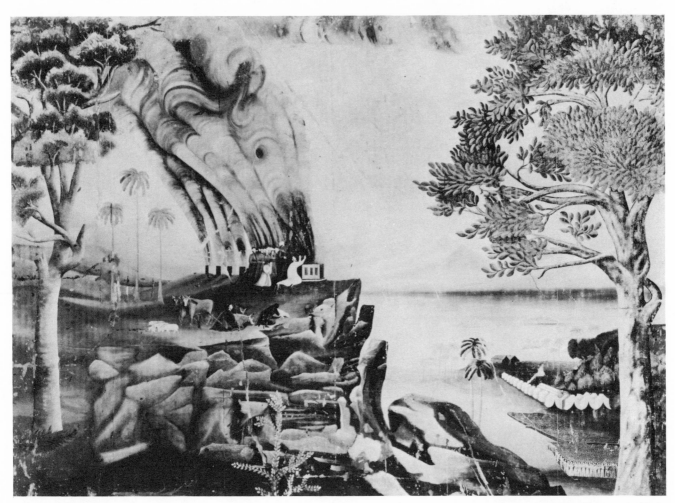

97. ELIJAH AND THE KING

Serrego House, Weymouth, Mass.

Fresco 1845

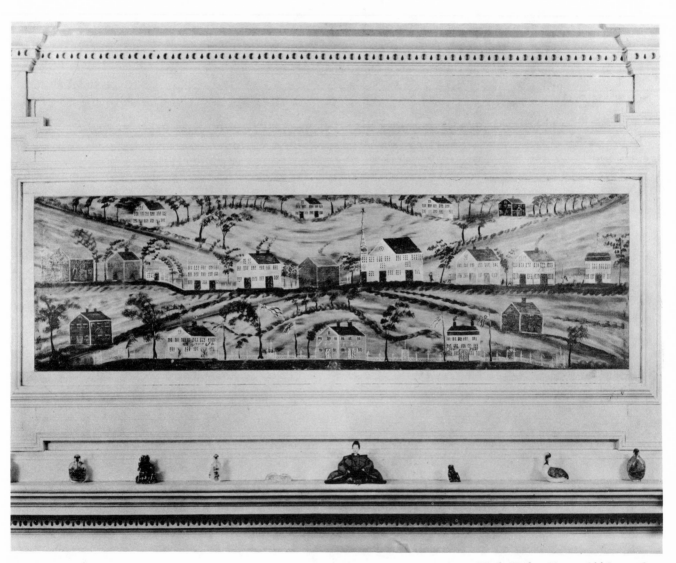

98. 'AMEN STREET'
Overmantel panel c.1800

Wade-Tinker House, Old Lyme, Conn.

Harry Stone, New York

99. OVERMANTEL PANEL
Pennsylvania Mid 18th century

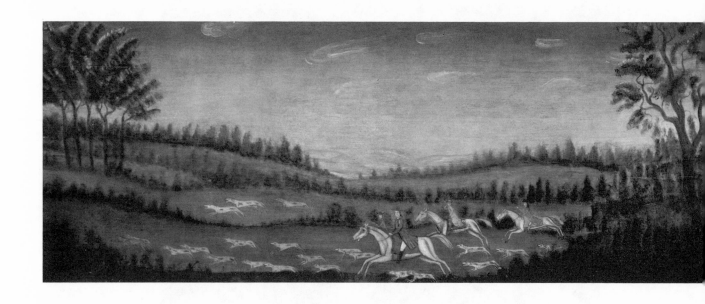

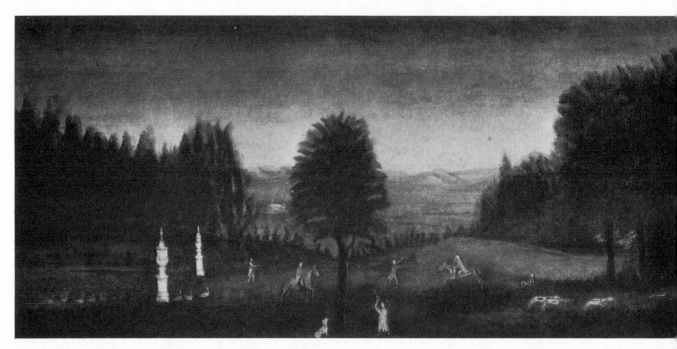

100. **PAINTED WALL PANELS**
Brooklyn, Conn. c.1800

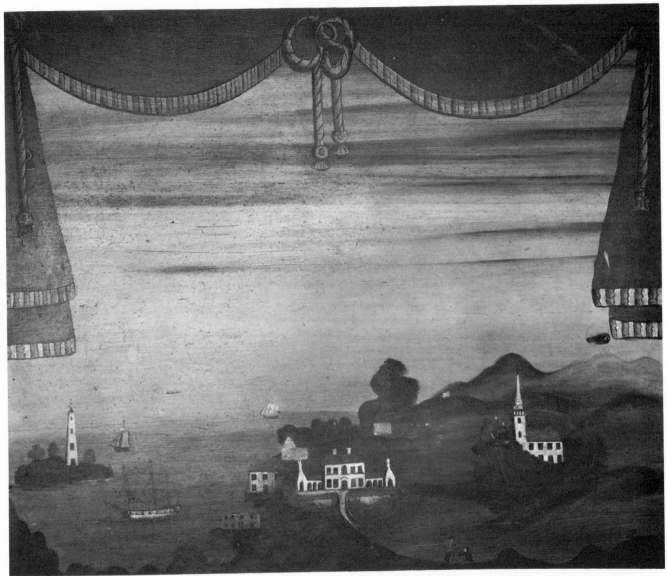

101. OVERMANTEL PANEL
c.1820

Palmer House, Canterbury, Conn.

Selected Bibliography

LISTED CHRONOLOGICALLY

BACKGROUND

Löwy, E., *The Rendering of Nature in Early Greek Art*, London, Duckworth, 1907.

Earle, A. M., *Two Centuries of Costume in America*, N.Y., Macmillan, 1910 (Dover reprint, 1970).

Clark, A. H., *The Clipper Ship Era*, N.Y., Putnam, 1910.

Wright, W. H., *Misinforming a Nation*, N.Y., B.W. Huebsch, 1917.

Andrews, C. M., *Colonial Folkways*, The Chronicler of America Series, v. VI, New Haven, Yale University Press, 1919.

Bolton, C. K., *The Founders*, Boston, Boston Athæneum, 1919.

Morgan, J. H., *Early American Painters*, N.Y., New York Historical Society, 1921.

Sherman, F. F., *Early Connecticut Artists and Craftsmen*, N.Y., privately printed, 1925.

Adams, J. T., *Provincial Society*, N.Y., Macmillan, 1927.

Fish, C. R., *The Rise of the Common Man* 1830-1850, N.Y., Macmillan, 1927.

Clarke, T. B., 'American Portraiture from 1585 to 1830,' in introductory section, Weddell, *Virginia Historical Portraiture*, Richmond, Byrd Press, 1930.

Beard, C. A. & M. R., 'Provincial America,' v. I, chapter I in *The Rise of American Civilization*, N.Y., Macmillan, 1930.

(Cahill, H. & Robinson, E. B.), Newark Museum Catalogue, *American Folk Sculpture*, Newark, 1931.

Sherman, F. F., *Early American Painting*, N.Y., Century, 1932.

Worcester Art Museum Catalogue, *Seventeenth Century Painting in New England*, Worcester, 1934.

Burroughs, A., *Limners and Likenesses*, Cambridge, Harvard University Press, 1936.

Metropolitan Museum of Art Catalogue, *Life in America*, N.Y., 1939.

Sherman, F. F., *Richard Jennys—New England Portrait Painter*, Springfield, Pond-Ekberg, 1941.

SOURCE MATERIAL

Dow, G. F., *The Arts and Crafts in New England* (Gleanings from Boston newspapers, 1704-75), Topsfield, Mass., Wayside Press, 1927.

Allston, J. W., *Hints to young Practitioners in the Study of Landscape Painting, to which are added Instructions in the Art of Painting in Velvet*, Edinburgh, 1804.

Turner, Maria, *Young Ladies' Assistant in Drawing and Painting*, Cincinnati, 1833.

Phelps, Almira, *The Female Student*, 1836.

Dickens, Charles, *American Notes*, N.Y., Cromwell & Co., n.d. (1842) (Concerning primitives, p. 397).

Dunlap, William, *A History of the Rise and Progress of the Arts of Design in the United States*, 1834 (Dover reprint, 1969).

Porter, Rufus, 'The Art of Painting', *Scientific American*, v. 1, nos. 10, 13, 19, 20-22, 26-30, (1845-6).

Memoirs of the Life and Religious Labors of Edward Hicks, Philadelphia, Merrilew, 1851.

Miscellaneous Extracts about Edward Hicks, author of the "Peacable Kingdom", compiled by the Newton Library Corporation, (unpublished manuscript), N.Y., Frick Art Reference Library, 1935.

Urbino, Levina, *Art Recreations*, Boston, S. W. Tilton & Co., editions 1859-84.

Twain, Mark, *Life on the Mississippi*, N.Y., Harper, n.d. (1874) (Concerning primitives, pp. 319-20).

French, H. W., *Art and Artists in Connecticut*, Boston, 1879.

ABOUT PRIMITIVE PAINTING

Allen, E. B., 'The Quaint Frescoes of New England,' *Art in America*, x (Oct. 1922), 263-74.

Sherman, F. F., 'Three New England Miniatures,' *Antiques*, IV (Dec. 1923), 275-6.

Sherman, F. F., 'Quaint Early Miniatures' & 'Miniature by J. S. Ellsworth,' *Art in America*, XI (June 1923), 208-13.

(Barker, V.), 'Notes on Exhibitions' (Early American Art at the Whitney Studio Club), *The Arts*, v (March 1924), 161, 164.

Goodrich, L., 'Early American Portraits' (on exhibition at Dudensing Galleries), *The Arts*, VII (Jan. 1925), 46-7.

Brook, A., 'Portrait Painters Incognito,' *Charm*, III (Feb. 1925), 38-9, 89.

Eglington, G., 'Art and Other Things,' *International Studio*, LXXX (Feb. 1925), 416-19.

Nelson, Mrs. H. C., 'Early American Primitives,' *International Studio*, LXXX (March 1925), 454-9.

Karr, L., 'Old Westwood Murals,' *Antiques*, IX (April 1926), 231-6.

Sherman, F. F., *James Sanford Ellsworth—a New England Miniaturist*, N.Y., privately printed, 1926.

Allen, E. B., *Early American Wall Painting*, New Haven, Yale University Press, 1926.

Keyes, H. E., 'Some American Primitives,' *Antiques*, XII (Aug. 1927), 118-22.

Ciolkowska, M., 'American Primitives,' *Artwork*, III (Sept. 1927), 176-9.

Stow, C. M., 'Primitive Art in America,' *The Antiquarian*, VIII (May 1927), 20-24.

Wright, R., *Hawkers and Walkers in Early America* ('The Artist as an Itinerant,' pp. 129-43), Philadelphia, Lippincott, 1927.

Harvard Society for Contemporary Art Catalogue, *American Folk Painting*, Cambridge, 1930.

Newark Museum Catalogue, *American Primitives*, Newark, 1930.

Sherman, F. F., 'American Miniatures by Minor Artists,' *Antiques*, XVII (May 1930), 422-5.

Robinson, E. B., 'American Primitive Paintings,' *Antiques*, XIX (Jan. 1931), 33-6.

Karr, L., 'Paintings on Velvet,' *Antiques*, XX (Sept. 1931), 162-5.

Cahill, H., 'American Folk Art,' *The American Mercury*, XXIV (Sept. 1931), 39-46.

Barker, V., *A Critical Introduction to American Painting* (includes list of 21 folk painters), N.Y., *Whitney Museum of American Art*, 1931.

Cahill, H., 'Folk Art, its Place in the American Tradition,' *Parnassus*, IV (March 1932), 1-4.

Cahill, H., 'Early Folk Art in America,' *Creative Art*, XI (Dec. 1932), 255-70.

Snow, J. D. S., 'King versus Ellsworth,' *Antiques*, XXI (March 1932) 118-21.

(Keyes, H. E.), 'The Editor's Attic: The Cover,' *Antiques*, XXI (May 1932), 211.

Sherman, F. F., 'Substantiation for Miss Snow,' *Antiques*, XXII (July 1932), 3-4.

(Cahill, H.), Museum of Modern Art Catalogue, *American Folk Art*, N.Y., 1932.

Albright Art Gallery Catalogue, *Centennial Exhibition—American Folk Art*, Buffalo, 1932.

Paxon, H. D. Jr., 'Edward Hicks and his Paintings,' pp. 1-4 in *A Collection of Papers Read before the Bucks County Historical Society*, Allentown, Pa., Berkemeyer, Keck & Co., 1932.

Keyes, H. E., 'Title Hunting Americana,' *Antiques*, XXIII (Feb. 1933), 59-61.

Rathbone, P. T., *Itinerant Portraiture in New York and New England 1820-1840* (unpublished manuscript), N.Y., Frick Art Reference Library, 1933.

Hughe, R., Ed., 'La peinture d'instinct,' chapt. 7 in *Histoire de l'art contemporain, la peinture,* Paris, 1934.

Barker, V., 'The Painting of the Middle Range,' *American Magazine of Art,* xxvii (May 1934), 232-40.

Francis, H. S., 'Water Colors Made by the "Theorem Method" and Drawings,' *Bulletin of the Cleveland Museum of Art,* xxi (Oct. 1934), 128-31.

Bye, A. E., 'Edward Hicks, Painter-Preacher,' *Antiques,* xxix (Jan. 1936), 13-16.

Sayre, A. H., 'Portrait Painting in America Today and its Ancestry,' *The Art News,* xxxiv (April 1936), 5, 7.

Downtown Gallery Catalogue, *Children in American Folk Art,* N.Y., 1937.

Waring, Janet, *Early American Stencils on Walls and Furniture,* N.Y., Scott, 1937 (Dover reprint, 1968).

Lowe, J., 'American Aquarellists, 1800-1938,' *The Art News,* xxxvi (Feb. 26, 1938), 9, 24.

Halpert, E. G., 'American Folk Art Painting,' *Design,* xxxix (Sept. 1937), 9-13.

Museum of Modern Art Catalogue, *Masters of Popular Painting,* N.Y., 1938.

Lipman, J., 'A Critical Definition of the American Primitive,' *Art in America,* xxvi (Oct. 1938), 171-7.

Sternbergh, D., 'Portraits on Glass,' *Coronet,* v (Feb. 1939), 55-8.

Brooklyn Museum Catalogue, *Popular Art in America,* Brooklyn, 1939.

Williamsburg Catalogue, *American Folk Art,* Williamsburg, 1940.

Carnegie Institute Catalogue, *Survey of American Painting,* Pittsburgh, 1940 (Includes discussion and reproduction of a few Primitives).

Hagen, O., 'Sunday Painters Defined,' pp. 23-7 in *The Birth of the American Tradition in Art,* N.Y., Scribner, 1940.

Carnegie Institute Catalogue, *American Provincial Paintings 1680-1860 from the Collection of J. Stuart Halladay and Herrel George Thomas,* Pittsburgh, 1941.

Halladay, J. S. & Thomas, H. G., 'American Provincial Paintings,' *Carnegie Magazine,* xv (May 1941), 35-8.

Sears, C. E., *Some American Primitives,* Boston, Houghton Mifflin, 1941.

Lipman, J., 'American Primitive Portraiture,' *Antiques,* xl (Sept. 1941), 142-4.

Saint-Gaudens, H., 'Our "Primitives",' pp. 14-18, 'Still more Primitives,' pp. 109-13, in *The American Artist and his Times,* N.Y., Dodd, Mead, 1941.

Janis, S., *They Taught Themselves,* N.Y., Dial Press, 1942.

Primitives Gallery of Harry Stone Catalogue, *One Hundred and Fifty Years of American Primitives,* N.Y., 1942.

Important Exhibitions

1924-1942

1924 Whitney Studio Club, N.Y.—Early American Art
 Dudensing Gallery, N.Y.—Early American Portraits and Landscapes
 Kent, Conn.—Portraits

1926 Isabel Carlton Wilde Studio, Cambridge, Mass.—American Primitives

1927 Whitney Studio Club, N.Y.—Isabel Carlton Wilde Collection

1930 Newark Museum—Primitives (Exhibition subsequently shown in the galleries of
 the Renaissance Society of Chicago and at the Toledo Museum)
 Harvard Society for Contemporary Art, Cambridge—American Folk Painting

1931 Hackett Galleries, N.Y.—Early American Paintings
 Downtown Gallery, N.Y.—American Ancestors
 Ferargil Galleries, N.Y.,—Early American Paintings
 Newark Museum—American Folk Sculpture

1932 Whitney Museum of American Art, N.Y.—Provincial Paintings
 Museum of Modern Art, N.Y.—Folk Art
 Folk Arts Center, N.Y.—Folk Arts
 Albright Art Gallery, Buffalo—American Folk Art
 Downtown Gallery, N.Y.—American Portraits
 John Becker Gallery, N.Y.—Isabel Carlton Wilde Collection of Early American
 Folk Painting

1933 Rhode Island School of Design, Providence—American Folk Art
 Folk Arts Center, N.Y.—New England Folk Arts
 Downtown Gallery, N.Y.—American Ancestors
 John Becker Gallery, N.Y.—Isabel Carlton Wilde Collection of Early American
 Folk Art

(143)

1935 Folk Arts Center, N.Y.—Pennsylvania German Folk Arts (including 8 paintings
 by Edward Hicks)
 Detroit Institute of Art—American Folk Art

1936 Downtown Gallery, N.Y.—Vital Statistics
 Folk Arts Center, N.Y.—Folk Arts from Nantucket Island
 Julian Levy Gallery, N.Y.—Isabel Carlton Wilde Collection of Early American
 Folk Art

1937 Downtown Gallery, N.Y.—Children in American Folk Art
 Denver Art Museum—American Folk Art

1938 Social Museum, Vassar College, Poughkeepsie—Folk Arts of the Hudson Valley
 Downtown Gallery, N.Y.—Americans at Home
 Downtown Gallery, N.Y.—American Watercolors and Pastels, 1800-1938
 Downtown Gallery, N.Y.—Genre in American Folk Art
 Folk Arts Center, N.Y.—Kentucky Folk Arts
 Museum of Modern Art, N.Y. (Young Folks' Gallery)—Selected Group of
 Folk Art

1939 Downtown Gallery, N.Y.—American Folk Art—Painting on Velvet, 1800-1840
 Brooklyn Museum—Popular Art in America
 Morton Galleries, N.Y.—Joseph Whiting Stock
 Folk Arts Center, N.Y.—Masterpieces of American Folk Arts

1940 M. Knoedler & Co., N.Y.—American Primitives
 Lord and Taylor, N.Y.—American Primitives (from the Horace W. Davis Col-
 lection)
 Folk Arts Center, N.Y.—Masterpieces of American Folk Art

1941 460 Park Avenue Gallery, N.Y.—30 American Primitives
 Downtown Gallery—Masterpieces in American Folk Art
 Berkshire Museum, Pittsfield, Mass.—American Primitive Paintings from the
 Collection of Horace W. Davis
 Virginia Museum of Fine Arts, Richmond, and Philadelphia Museum of Art—
 Collection of Walter P. Chrysler, Jr.
 Museum of Fine Arts, Springfield—Portraits, Landscapes, Still Life
 Carnegie Institute, Pittsburgh—American Provincial Paintings (from the private
 collection of J. S. Halladay and H. G. Thomas)
 Schneider-Gabriel Galleries, N.Y.—The Art of an American People (from the
 Fred J. Johnson Collection)

Gourielli Shop, N.Y.—Primitive Portraits of Children (from the Helena Rubinstein Collection)

Folk Arts Center, N.Y.—Masterpieces of American Folk Arts

Taft Museum, Cincinnati—Harden De V. Pratt Collection of American Folk Art

1942 Springfield Museum of Fine Arts—Somebody's Ancestors (including 25 paintings by Erastus Salisbury Field)

Primitives Gallery of Harry Stone, N.Y.—One Hundred and Fifty Years of American Primitives

Downtown Gallery, N.Y.—Battles and Symbols of the U.S.A.

Primitive Painters

KNOWN BY NAME

THOUGH the great majority of our American Primitive painters remain completely unknown, some names have emerged from this typical condition of anonymity. Among the most noteworthy of these painters whose lives and work are at least partially known to us are the following, who include a miniature painter, a portrait painter, three scene painters, an itinerant wall decorator, and a lady watercolorist.

JAMES SANFORD ELLSWORTH worked chiefly in Windsor and Norwich, Conn. He was born in 1811 and died in 1873 or 1874. He painted miniature portraits in watercolor, almost invariably on thin paper. For a detailed account of his life and work see *James Sanford Ellsworth* by Frederic Fairchild Sherman.

JOSEPH H. HEADLEY, who lived in the vicinity of Troy, New York, worked from about 1840 to 1860. He painted in oil on canvas and wood a number of remarkable New York landscapes and village scenes.

EDWARD HICKS was born in Attleborough, Bucks County, Pa., in 1780 and died in Newtown in 1849. Beginning his career as a house, sign, and coach painter, he became a minister and a painter of various types of scenes. A good account of his life and work can be found in the Museum of Modern Art Catalogue, *American Folk Art,* 1932, pp. 31-2.

JOSEPH PICKETT, 1848-1918, lived and died in New Hope, Pa. He is known by only a few large scenes which he painted late in his life, using ordinary house paint on canvas. See the Catalogue listed above, pp. 33-4, for further details.

(147)

EUNICE PINNEY, 1770-1849, was born in Simsbury, Conn., but lived and worked in Windsor. She painted a large number of unusual watercolors, of all types of subjects. Many examples of these have found their way into collections of American Primitives.

RUFUS PORTER, 1792-1884, was born in Boxford, Mass., and died in New Haven, Conn. His career included, successively, the vocations of shoemaker, fife and violin player, house and sign painter, itinerant school-teacher, inventor, itinerant limner and mural landscape painter, editor of the *American Mechanic,* and founder and editor of the *Scientific American.* For a fuller life history see the *Dictionary of American Biography,* vol. 15.

JOSEPH WHITNEY STOCK, 1815-55, was born and lived in Springfield, Mass. He advertised as a painter of portraits, landscapes, and banners, but only his oil portraits have been found to date. For details see the 1932 Museum of Modern Art Catalogue, pp. 29-30.

* * *

The lists of American Primitive painters which follow have been compiled from all pertinent books, magazine articles, and exhibition catalogues and from primitive pictures seen over a period of years. I wish especially to acknowledge as sources a list of about one hundred of these painters which Messrs. J. S. Halladay and H. G. Thomas most generously turned over to me for inclusion in this book; Clara Endicott Sears' *Some American Primitives;* Virgil Barker's *A Critical Introduction to American Painting;* the Museum of Modern Art and the Newark Museum exhibition catalogues; the Carnegie Institute exhibition catalogue for the Halladay-Thomas collection; the numerous Downtown Gallery exhibition catalogues; and the catalogues for the Rockefeller Collection at Williamsburg and for the Walter P. Chrysler, Jr. Collection.

A considerable number of the painters listed on the following pages are fairly well known today; some are known only by two or three pictures; many are merely identified because of having signed their names to an isolated painting. Listing a number of these typical primitive painters provides a cross-section basis for estimating the number of such painters active in the late eighteenth and nineteenth centuries, where and when the majority of them worked, what subjects they most frequently painted, and what media they chiefly used. A more important reason for listing these names is the possibility that some of them may prove to be the core around which a body of work will at some future time be assembled.

NAME	LOCALE	DATE	SUBJECT	MEDIUM
John Abbe	New York	1820	Portraits	Watercolor
Charlotte Adams	Amenia, N. Y.	1830	Still life	Velvet painting
Willis Seaver Adams	Springfield, Mass.		Portraits	
Jos. E. Adelman	Yorktown, Va.	1860	Scene	
G. Alden	Mass.	1840	Portraits	Oil
Noah Alden	Middleboro, Mass.	1830	Portraits	
Francis Alexander	Windham County, Conn.	b. 1800	Portraits	Oil, watercolor and pastel
George W. Appleton	Maine	1830	Portraits	
A. Arnold	New York	1860	Village scene	Oil
Ashbery	Chambersburg, Pa.		Scene	Oil on cardboard
Jeremiah Atwood	Mass.		Portraits	
Jean Aubry	Mass.	1830-40	Portraits	Oil
John Avery	Wolfeboro, N. H.	1820	Mural landscapes	Fresco
Mary Ann Bacon	Litchfield, Conn.	1850	Landscape	
S. S. Bannon			Scenes	Oil
James Bard		1850	Ship picture	Oil
Lewis Bardick	New York	1870	Portrait of dog	Oil
Lucius Barnes	Middletown, Conn.	1810-30	Portraits	Watercolor
Julia Fuller Barnum	Kent, Conn.		Landscape	
Salome Barstow	Mass.	1820	Still life	Velvet painting
Lucy Bartlett	Mass.	1830	Memorial	Velvet painting
Wm. Thompson Bartol	Marblehead, Mass.	1845	Portraits	Oil
Ruth Henshaw Bascom	Mass.	1772-1830*	Portraits	Pastel
O. I. Bears	New London, Conn.	1835	Portraits	Oil
C. G. Beauregard	Mass.	1840	Portraits	Oil
Joseph Becker	Sacramento, Cal.	1841-1910*	Scene	Oil
Martha Stuart Beers	New Lebanon, N. Y.	1830	Still life	Velvet painting
M. D. Belcher	Greenfield, Mass.	1830	Landscape	Watercolor
Zedekiah Belknap	Mass.	1810-40	Portraits of sea captains	Oil
Jonnie E. Berry		1865	Portraits	Pastel
David Bixler	Ephrata, Pa.	1830	Equestrian portrait	
E. W. Blake			Children's portraits	Oil
Alexandre Boudrou	Penn.	1850	Scenes	Oil
Boutwell	Groton, Mass.	1850	Mural scenes	Fresco

Unless otherwise specified, oils are on canvas, watercolors and pastels on paper. The dates, unless followed by an asterisk, signifying birth and death dates, indicate approximate period of activity.

NAME	LOCALE	DATE	SUBJECT	MEDIUM
M. Boyle	Carlisle, Pa.	1850	Historical scene and still life	Oil
I. Bradley	probably Philadelphia, Pa.	1830	Portrait	Oil
Mary Bradley	Lee, Mass.	1830	Still life	Velvet painting
Brewer	N. H. and Vt.		Children's portraits	Oil
John Brewster	Portland, Me.	1830	Children's portraits	Oil
Hugh Bridport	Mass.	1820	Portraits	Oil
L. A. Briggs	Boston, Mass.	1850	Ship pictures	Watercolor
Dr. Samuel Broadbent	Wethersfield, Conn.	b. 1759	Portraits	Oil
Newton Brooks	Mass. and N. H.		Portraits	
A. Bullard	Westerly, R. I.	1850	Portrait	Pastel
H. Bundy	Claremont, N. H.	1837-50	Portraits	Oil
Leonard Burr	Mass.	1840	Portraits	Oil
Asa Bushby	Danvers, Mass.	1840	Portraits	
Esteria Butler	Maine	1820	Miniature portraits	Oil
Hannah P. Buxton	New York	1820	Memorial	Velvet painting
Emma Cady	New Lebanon, N. Y.	1820	Still life	Watercolor
Pryse Campbell		1770	Portraits	Oil
Azel Capen	Maine	1840	Portraits	Oil
Joseph Carey	Salem, Mass.	1785	Scene	Oil on wood
Joseph Goodhue Chandler	Boston, Mass.	1840 b. 1813	Portraits	Oil
Winthrop Chandler	Mass. and Conn.	1747-90*	Portraits	Oil
Alvan Clark	Mass. and R. I.	1804-64*	Portraits	Oil and watercolor
Eliz. Potter Clark	New London, Conn.	1830	Still life	Velvet painting
Minerva Clark		1840	Portraits	Oil
David Clarke			Still life	Watercolor
Harriet B. Clarke	New York	1820	Memorial	Velvet painting
William P. Codman	Boston, Mass.	1805	Portraits	Oil
Charles Octavius Cole	Newburyport, Mass.	1830-40	Portraits of sea captains	Oil
Lyman Emerson Cole	Newburyport, Mass.	1830-40	Portraits of sea captains	Oil
Major Cole	New Hampshire	1810	Portraits	Oil
Maria Cole	Cheshire, Mass.	1830	Still life	Velvet painting
John Coles, Jr.	Boston, Mass.	1807-20	Portraits	Oil
Miss Collis	Rhode Island	1830	Still life	Watercolor
Maria T. Conant	Cambridge, N. Y.	1840	Portraits	Oil

NAME	LOCALE	DATE	SUBJECT	MEDIUM
Mehitable J. Cook	Maine	1830	Portraits	Oil
J. D. Cortwright	Lowell, Mass.	1840	Portraits	Tempera
Eleanor L. Coward			Still life	Velvet painting
James Coyle	Mass.		Portraits	
Aphia Crawford		1850	Portraits	Watercolor
Hannah Crowninshield	Mass.	1815	Portraits	Oil
Charles Curtis	Worcester, Mass.	1820	Portraits and miniatures	Oil
Mary Cushman	Rhode Island	1800	Memorial	Watercolor on silk
J. Dalee	Cambridge, N. Y.	1830	Scene	Watercolor
M. J. Dalzell			Genre	Watercolor
Capt. Geo. Davidson	Mass.	1790	Portraits	Oil
Eben Davis	Mass.	1850	Portraits	Watercolor
E. P. Davis	Mass.	1820	Scene	Watercolor
Polly C. Dean	Mass.	1820	Memorial	Velvet painting
Dobson	Mass.		Portraits	
Lucy Douglas		1810	Religious picture	Watercolor
William M. S. Doyle	Mass.	1820	Portraits	Pastel
Anthony Drexel	Mass.	1830	Portraits	Oil
C. F. Dunn	N. Litchfield, Me.	1850	Landscapes	Watercolor
George H. Durfee	New York	1865	Landscapes	Watercolor
J. N. Eaton	Greene, N. Y.	1800	Conversation piece	Oil
James Eights	Albany, N. Y.	1850	Landscape	
Rachel E. Ellis	Franklin, N. H.	1820	Memorial	Watercolor on silk
William S. Elwell	Springfield, Mass.	1810-81*	Portraits	Oil
I. L. Emerson			Ship picture	Oil
Alexander Hamilton Emmons	Norwich, Conn.	1816-79*	Portraits	Oil and watercolor
John Ewen, Jr.		late 18th cent.	Scene	Oil on wood
R. Fibich	York Springs, Pa.	1850	Landscape	Oil
Erastus Salisbury Field	Mass.	1805-1900*	Portraits and scenes	Oil
E. E. Finch	Maine	1850	Portraits	Oil
Albert Fischer	Boston, Mass.	1792-1863*	Portraits	Oil
Charles Henry Fischer	Newark, N. J.	1860	Scenes	Oil
Jonathan Fisher	Maine	1825	Portraits	Oil
Fletcher	N. H. and Vt.		Portraits	
Nicholas Foley	Conn.	1825	Romantic scene	Oil on wood

NAME	LOCALE	DATE	SUBJECT	MEDIUM
Fordham	Springfield, Mass.		Portraits	
Geo. Fredenburg		1830	Still life	Watercolor
C. French	Mass.	1810	Portraits	Oil
O. E. S. Frink	Medford, Mass.		Portraits and landscapes	
James Frothingham	Boston and Salem, Mass., New York City	1786-1864*	Portraits	Oil
John Mason Furnass	Mass.	1785	Portraits	Oil
George Gasner	Mass.	1811-61*	Portraits and miniatures	Oil
Charles S. Gibson			Children's portraits	Oil
C. M. Giddings	Cleveland, Ohio	1840	Scenes	Oil
E. J. Gilbert	Maine	1850	Mural scenes	Fresco
J. Gilbert	New Bedford, Mass.		Portraits	
A. W. S. Gilpin			Still life	Watercolor
Benj. Gladding	Providence, R. I.	1810	Genre	Oil
C. H. Golder		1880	Scene	Oil
D. Goldsmith		1830	Group portrait	Watercolor
J. C. Goodell	Malden Bridge, N. Y.	1830	Portraits	Oil
F. W. Goodwin		1830	Portraits	Oil
Charles H. Granger	Maine	1840	Portraits	Oil
Benjamin Greenleaf	Phippsburg, Me., and Mass.	1820-40	Portraits	Oil on canvas and glass
Charles Grinniss	Conn.		Portraits	
J. H. Grout			Portraits	
Thomas Gurney		1815	Memorials, valentines	Watercolor
Sylvester Hall	Wallingford, Conn.	1778	Mural landscape	Oil on wood
L. J. Hamblin	Boston, Mass.	1840	Portraits	Tempera
Amos Hamilton	Mass.	1830	Portraits	Oil
Nathaniel Hancock	Boston and Salem, Mass.	1790-1808	Portraits	Oil
Jeremiah L. Harding	Mass.	1840	Portraits	Oil
Jeremiah P. Hardy	Maine	1840	Portraits	Oil
Harriet A. Harris		1880	Landscape	Oil
Alonzo Hartwell	Mass.	1835	Portraits	Oil
Elisha Hatch	Canaan, N. Y.	1840	Portraits	Watercolor
Dr. Rufus Hathaway	Mass.	1790	Portraits	Oil
Matilda A. Haviland			Still life	Velvet painting
Sarah E. Hawes	Mass.	1810	Memorial	Watercolor

NAME	LOCALE	DATE	SUBJECT	MEDIUM
Martha S. Hayse	Mass.	1810	Landscape	Watercolor
John Hazlitt	Hingham, Mass.	1767-1837*	Mural landscapes	Oil on wood
Hering	New Jersey	1785-1817	Portraits	Oil
Amasa Hewins	Dedham, Mass.		Portraits	
Philip Hewins	Hartford, Conn.	1806-1850	Portraits	Oil
William Hillyer	New Jersey	1830	Portraits	Oil
Albert Gallatin Hoit	Boston, Mass.	1800-1856	Portraits	Oil
E. R. Hood	Portsmouth, N. H.		Landscape	
Lydia Hosmer	Concord, Mass.	1810-20	Still life	Velvet painting
Thomas Hoyt	Bangor, Me.	1850	Portraits	Oil
Hubbard		1820-40	Portraits	Oil
William Hudson, Jr.	Boston, Mass.	1830	Portraits	Oil
I. F. Huge	Bridgeport, Conn.	1845	Ship pictures	
Robert Ball Hughes	Boston, Mass.	1830	Portraits	Oil
Ingalls	New Hampshire	1850	Portraits and miniatures	Oil
Mary L. Ingraham	Mass.	1810	Religious scene	Watercolor
H. Jenkins		1850	Portraits	Oil
N. D. Jenney	Portland, Me.	1850	Portraits	Oil
J. S. Jennings	New Hudson, N. Y.	1850	Landscape	Oil
Frederic Stiles Jewett	Hartford, Conn.	1819-64*	Ship pictures	
Ann Johnson	Conn.	1810-25	Religious scene	Watercolor
S. D. Johnson		1820	Landscape	Watercolor
John Johnston	York, Me.	1790	Portraits	Oil
Jones of Conn.	Conn.	1850	Portraits	Watercolor
S. Jordon	New York	1830	Portraits	Oil
W. H. Kelly		1870	Scene	Oil on wood
A. Kemmelmeyer	Maryland	1790-1810	Hist. scenes of Gen. Washington	Oil
William W. Kennedy		1845	Portraits	
Jane Keys	Troy, N. Y.	1825	Instructress in painting and embroidery	
Mary Ann Kimball	Penn.	1825	Memorial	Velvet painting
Charles King	Maine	1850	Portraits	Oil
Josiah King	Conn.	1850	Miniature portraits	Watercolor
Addison Kingsley		1860	Landscape	Oil
T. G. Knight	Penn.	1880	Genre	Oil
Nathaniel Lakeman	Mass.	1780-90	Portraits	Oil

NAME	LOCALE	DATE	SUBJECT	MEDIUM
Betsy B. Lathrop	New York	1810	Biblical scene	Watercolor on silk
Thomas B. Lawson	Mass.	1840	Portraits	
C. L. Levin	Penn.	1850	Portrait	Oil
Elijah P. Lewis	Maine	1830	Portraits	Oil
James Lincoln	Mass.	1840	Portraits	Oil
Ann Little	Mass.	1820	Landscape	
William Lovett	Mass.	1790	Portraits	Oil
H. Lyman	Conn.	1820	Instructress in painting	
Emily Eastman Louden	New Hampshire	1820	Portraits	Watercolor
Edward D. Marchant	Mass.	1830	Portraits	Oil
Mirible Marford	Eatontown, N. J.	1814-27*	Landscape	Watercolor
C. W. Mark		1830	Romantic scenes	Oil
Emily Marshall	White Plains, N. Y.	1810	Mythological subjects	Watercolor
J. B. Marston	Boston, Mass.	1810	Portraits	Oil
G. Martens		1840	Portrait	Oil
Benjamin Franklin Mason	Pomfret, Vt.	1825	Group portrait	Oil
Jonathan Mason	Mass.	1820-30	Portraits	Oil
William Sanford Mason	Mass.	1840	Portraits	Oil
Eliza McClellan Mayall	Maine	1840	Portraits	Oil
J. McAuliffe		1830-70	Genre	Velvet painting
R. McFarlane		1840	Portraits	Oil
McKay	Conn.	1790	Portraits	Oil
A. C. McLean	Charlestown, Mass.	1830	Portrait of children	Oil
Elizabeth Meyer	Penn.	1830	Animals	Watercolor
Louisa F. Miller	New Lebanon, N. Y.	1830	Memorial	Watercolor on silk
Phoebe Mitchell	New York	1800-1810	Landscape	Watercolor
A. E. Moore		1830	Portrait	Oil
J. Moron	Mass.	1830	Portrait	Oil
Jones Fawson Morris	Sterling, Mass.	1840	Portraits	Oil
Emeline Morton			Scene	Watercolor
Thomas P. Moses	Portsmouth, N. H.	1850	Ship picture	Oil
Reuben Moulthrop	Mass.	1790	Portraits	Oil
George Munger	Mass.	1810	Portraits	Oil
Elenor Murray	Red Bank, N. J.	1820	Romantic scene	Watercolor
J. D. Neffensperger	Penn.	1840	Scene	Watercolor and ink
Nathan Negus	Mass. & Alabama	1850	Portraits	
G. N. Newell			Portrait	

NAME	LOCALE	DATE	SUBJECT	MEDIUM
Susan Fauntleroy Quarles Nicholson	Baltimore, Md.	1820	Portraits	Oil
Mary Altha Nims	Bennington, Vt.	1840	Romantic scenes	Watercolor
John Norman	Mass.	1775	Portraits	Oil
Benjamin F. Nutting	Boston, Mass.	b. 1813 d. after 1873	Portraits	Oil
W. Oliver	Mass.	1870	Farm scene	Oil
N. B. Onthank	N. Y. & Mass.	1850	Portraits	
E. Opper	New York	1880	Genre	Oil
Alfred Ordway	Mass.	1840	Portraits	Oil
B. F. Osborn	Hampton, N. H.	1870	Marine	Oil
James Osborn		1800	Portrait	Watercolor
Charles Osgood	Mass.	1840	Portraits	Oil
Samuel Stillman Osgood	Mass.	1840	Portraits	Oil
William Page	Mass.	1840	Portraits	Oil
C. H. Palmer	Penn.	1825	Portraits	Oil
Linton Park	Indiana County, Pa.	1826-c.1870*	Genre	Oil
Jeremiah Paul	Philadelphia, Pa.	1790	Portraits	Oil
Deacon Robert Peckham	Westminster, Mass.	1785-1877*	Portraits	Oil
J. Peters	Vermont	1840	Genre	Oil
P. Mignon Pimat	Mass.	1810	Portraits	Oil
Plattenberger	Penn.	1860	Biblical scene	Oil
Edward Plummer	Conn.	1850	Miniature portraits	Watercolor
Harrison Plummer	Haverhill, Mass.	1840	Portraits	Oil
Luke Pollard	Harvard, Mass.	1845	Portraits	Oil
John Porter	Boston, Mass.	1830	Portraits	Oil
Henry C. Pratt	Maine	1840	Portraits	Oil
Luke B. Prince, Jr.	Haverhill, Mass.	1840	Portrait	
William Mathew Prior	Mass.	1806-73*	Portraits and landscapes	Oil and tempera on canvas and cardboard
Charlie Purdy	Salem, Mass.		Portraits	
J. Rasmussen	Berks County, Pa.	1880	Scene	Oil on zinc
P. Reed	Mass.	1840		
Marvin S. Roberts	Mass.	1813-72*	Portraits	Oil
Frank Robinson		1860	Ship picture	Watercolor and pencil
S. Roesen	Williamsport, Pa.	1860-70	Still life	Oil
Nathaniel Rogers	Mass.	1810	Portraits	Oil

NAME	LOCALE	DATE	SUBJECT	MEDIUM
George Ropes	Salem, Mass.	1850	Landscape	
L. K. Rowe	Mass.	1860	Portrait	Oil
Samuel Rowell	Amesbury, Mass.	1815	Portraits	Oil
Thomas Ruckle	Baltimore, Md.	1850	Landscape	
Ester Sackett	New York	1840	Still life	Watercolor
Ann Elizabeth Salter	Mass.	1810	Memorial	Velvet painting
J. W. Sawin	Springfield, Mass.	1850	Landscape	Oil
Belinda Sawyer		1820	Still life	
Caroline Schetky	Boston, Mass.	1815	Portraits	Oil
Isaac Sheffield	New London, Conn.	1798-1845*	Portraits of sea captains	Oil
Lucy McFarland Sherman	Peekskill, N. Y.	1850	Still life	Watercolor
John H. Smith	Thomaston, Me.	1875	Historical scene	Watercolor
Roswell T. Smith	Nashua, N. H.	1860	Portraits	Oil
Jenny Emily Snow	Hinsdale, Mass.	1845	Landscapes and Biblical scenes	Oil
Philip Snyder	Schoharie, N. Y.	1830	Scene	Oil
Lorenzo Somerby	Mass.	1840 b.1816	Portraits	Oil
George Southward	Mass.	1830	Portraits	Oil
Thomas T. Spear	Mass.	1830	Portraits	Oil
Frederick B. Spencer		1840	Portraits	Oil
Harry L. Spencer			Scene	Oil
J. W. Stancliff	Hartford, Conn.	1860 b.1814	Ship pictures	
A. Stanwood		1850	Scene	Oil
Arnold Steere	Rhode Island	1792-1832*	Portraits	Oil
Mary E. Sterling	Painesville, Ohio	1860	Scene	Oil
Mehetable Stickney		1825	Memorial	
Jeremiah Stiles	Mass.	1790	Portraits	Oil
Samuel Stiles	Mass.	1820	Portraits	Oil
Robert Street	Philadelphia, Pa.	1830-40	Portraits	Oil
William Swain	Mass.	1825	Portraits	Oil
Ann Waterman Swift	Poughkeepsie, N. Y.	1810	Romantic scene	Watercolor
William Talcott	Mass.	1820-36	Portraits	Oil
A. M. Taylor	New York	1825	Landscape	Watercolor
Charles Ryall Taylor		1860	Scenes	Oil
M. B. Tenney		1840	Portraits	
Sarah F. Terry	Mass.		Still life	Velvet painting
Cephas Thompson	Bath, Me.	1835	Portraits	Oil
William Thompson	Harvard, Mass.	1840	Portraits	Oil
Jerome Thomson	Mass.	1835	Portraits	Oil

NAME	LOCALE	DATE	SUBJECT	MEDIUM
Sarah Thomson	Mass.	1800	Portraits	Oil
Elizabeth Thurston	Canaan, Conn.	1820	Memorial	Watercolor on silk
Elizabeth Tillou	Brooklyn, N. Y.	1830	Still life	Watercolor
Philip Tilyard	Mass.	1810	Portraits	Oil
John Tolman	Boston & Salem, Mass.	1815	Portraits	Oil
Jona Treadwell	Readfield, Me.	1840	Portraits	Oil
Mary B. Tucker	Mass.	1840	Portrait	Watercolor
M. Van Doort	Mass.	1825	Portraits	Oil
Elizabeth L. Walker	Mass.	1840	Romantic scene	Watercolor
H. Ward	Youngstown, Ohio	1840	Scene	Watercolor
Catherine Townsend Warner	Rhode Island	1810	Memorial	Watercolor on silk
M. Warren, Jr.	White Plains, N. Y.	1830	Portraits	Watercolor
Almira Waters	Portland, Me.	1830	Still life	Watercolor
D. E. Waters		1840		Watercolor
E. Webb			Historical picture	Oil on glass
Betsy Wellman		1840	Equestrian portrait	Watercolor
T. H. Wentworth		1820	Portraits	Watercolor
A. S. Western	Boston, Mass.	1820	Landscape	Oil
Isaac A. Wetherbee	Boston, Mass.	1840	Portraits	Oil
Susan Whitcomb	Brandon, Vt.	1840	Scene	Watercolor
Ebenezer Baker White	Providence, R. I.	1840 b.1806	Portraits	Oil
John White	Cheshire, Conn.	1850	Landscape	Oil
L. Whitney			Village scene	Oil
Alfred J. Wiggin		1850	Portraits	
F. H. Wilder	Mass.	1850	Portraits	Oil
Matilda Wilder	Mass.	1820	Scene	Watercolor
John Wilkie		1840	Portraits	Oil
Sarah Wilkins	Mass.	1830	Memorial	Watercolor
Micah Williams	Peekskill, N. Y.	1790	Portraits	Oil
E. Wilson	New Hampshire		Portraits	Oil
Mary R. Wilson	Mass.	1820	Still life	Watercolor
William Winstanley	Philadelphia, Pa.	1800	Portraits	Oil
Hanna Wood	New Hampshire	1870	Portrait	Watercolor
J. A. Woodin	Palmyra, N. Y.	1830	Portraits	Watercolor
E. Woolson	Mass.	1843	Portraits	Oil on wood
Charlotte A. Woolworth	New Haven, Conn.	1865	Dog	
Almira Kidder Wright	Vermont	early 19th cent.	Historical scene	Watercolor on silk

NAME	LOCALE	DATE	SUBJECT	MEDIUM
Emma T. Wynkoop	Penn.	1870	Landscape	Oil
J. Harvey Young	Boston, Mass.	1860 b.1830	Portraits	Oil
H. Zeigler		1840	Portraits	Watercolor

Dover Books on Art

THE FOUR BOOKS OF ARCHITECTURE, Andrea Palladio. A compendium of the art of Andrea Palladio, one of the most celebrated architects of the Renaissance, including 250 magnificently-engraved plates showing edifices either of Palladio's design or reconstructed (in these drawings) by him from classical ruins and contemporary accounts. 257 plates. xxiv + 119pp. 9½ x 12¾. 21308-0 Paperbound $7.50

150 MASTERPIECES OF DRAWING, A. Toney. Selected by a gifted artist and teacher, these are some of the finest drawings produced by Western artists from the early 15th to the end of the 18th centuries. Excellent reproductions of drawings by Rembrandt, Bruegel, Raphael, Watteau, and other familiar masters, as well as works by lesser known but brilliant artists. 150 plates. xviii + 150pp. 5⅜ x 11¼. 21032-4 Paperbound $4.00

MORE DRAWINGS BY HEINRICH KLEY. Another collection of the graphic, vivid sketches of Heinrich Kley, one of the most diabolically talented cartoonists of our century. The sketches take in every aspect of human life: nothing is too sacred for him to ridicule, no one too eminent for him to satirize. 158 drawings you will not easily forget. iv + 104pp. 7⅜ x 10¾.

20041-8 Paperbound $2.75

THE TRIUMPH OF MAXIMILIAN I, 137 Woodcuts by Hans Burgkmair and Others. This is one of the world's great art monuments, a series of magnificent woodcuts executed by the most important artists in the German realms as part of an elaborate plan by Maximilian I, ruler of the Holy Roman Empire, to commemorate his own name, dynasty, and achievements. 137 plates. New translation of descriptive text, notes, and bibliography prepared by Stanley Appelbaum. Special section of 10pp. containing a reduced version of the entire Triumph. x + 169pp. 11⅛ x 9¼. 21207-6 Paperbound $5.95

PAINTING IN ISLAM, Sir Thomas W. Arnold. This scholarly study puts Islamic painting in its social and religious context and examines its relation to Islamic civilization in general. 65 full-page plates illustrate the text and give outstanding examples of Islamic art. 4 appendices. Index of mss. referred to. General Index. xxiv + 159pp. 6⅝ x 9¼. 21310-2 Paperbound $4.00

THE MATERIALS AND TECHNIQUES OF MEDIEVAL PAINTING, D. V. Thompson. An invaluable study of carriers and grounds, binding media, pigments, metals used in painting, al fresco and al secco techniques, burnishing, etc. used by the medieval masters. Preface by Bernard Berenson. 239pp. 5⅜ x 8.

20327-1 Paperbound $3.50

THE HISTORY AND TECHNIQUE OF LETTERING, A. Nesbitt. A thorough history of lettering from the ancient Egyptians to the present, and a 65-page course in lettering for artists. Every major development in lettering history is illustrated by a complete aphabet. Fully analyzes such masters as Caslon, Koch, Garamont, Jenson, and many more. 89 alphabets, 165 other specimens. 317pp. 7½ x 10½. 20427-8 Paperbound $4.50

VASARI ON TECHNIQUE, G. Vasari. Pupil of Michelangelo, outstanding biographer of Renaissance artists reveals technical methods of his day. Marble, bronze, fresco painting, mosaics, engraving, stained glass, rustic ware, etc. Only English translation, extensively annotated by G. Baldwin Brown. 18 plates. 342pp. 5⅜ x 8. 20717-X Paperbound $5.00

FOOT-HIGH LETTERS: A GUIDE TO LETTERING, M. Price. 28 15½ x 22½" plates, give classic Roman alphabet, one foot high per letter, plus 9 other 2" high letter forms for each letter. 16 page syllabus. Ideal for lettering classes, home study. 28 plates in box. 20238-9 $8.50

A HANDBOOK OF WEAVES, G. H. Oelsner. Most complete book of weaves, fully explained, differentiated, illustrated. Plain weaves, irregular, double-stitched, filling satins; derivative, basket, rib weaves; steep, broken, herringbone, twills, lace, tricot, many others. Translated, revised by S. S. Dale; supplement on analysis of weaves. Bible for all handweavers. 1875 illustrations. 410pp. 6⅛ x 9¼. 23169-0 Paperbound $5.00

JAPANESE HOMES AND THEIR SURROUNDINGS, E. S. Morse. Classic describes, analyses, illustrates all aspects of traditional Japanese home, from plan and structure to appointments, furniture, etc. Published in 1886, before Japanese architecture was contaminated by Western, this is strikingly modern in beautiful, functional approach to living. Indispensable to every architect, interior decorator, designer. 307 illustrations. Glossary. 410pp. 5⅝ x 8⅜. 20746-3 Paperbound $4.50

THE DRAWINGS OF HEINRICH KLEY. Uncut publication of long-sought-after sketchbooks of satiric, ironic iconoclast. Remarkable fantasy, weird symbolism, brilliant technique make Kley a shocking experience to layman, endless source of ideas, techniques for artist. 200 drawings, original size, captions translated. Introduction. 136pp. 6 x 9. 20024-8 Paperbound $3.00

COSTUMES OF THE ANCIENTS, Thomas Hope. Beautiful, clear, sharp line drawings of Greek and Roman figures in full costume, by noted artist and antiquary of early 19th century. Dress, armor, divinities, masks, etc. Invaluable sourcebook for costumers, designers, first-rate picture file for illustrators, commercial artists. Introductory text by Hope. 300 plates. 6 x 9. 20021-3 Paperbound $4.50

EPOCHS OF CHINESE AND JAPANESE ART, E. Fenollosa. Classic study of pre-20th century Oriental art, revealing, as does no other book, the important interrelationships between the art of China and Japan and their history and sociology. Illustrations include ancient bronzes, Buddhist paintings by Kobo Daishi, scroll paintings by Toba Sojo, prints by Nobusane, screens by Korin, woodcuts by Hokusai, Koryusai, Utamaro, Hiroshige and scores of other pieces by Chinese and Japanese masters. Biographical preface. Notes. Index. 242 illustrations. Total of lii + 439pp. plus 174 plates. 5⅝ x 8¼.
 20364-6, 20265-4 Two-volume set, Paperbound $8.00

200 DECORATIVE TITLE-PAGES, edited by A. Nesbitt. Fascinating and informative from a historical point of view, this beautiful collection of decorated titles will be a great inspiration to students of design, commercial artists, advertising designers, etc. A complete survey of the genre from the first known decorated title to work in the first decades of this century. Bibliography and sources of the plates. 222pp. 8⅜ x 11¼.

21264-5 Paperbound $5.00

ON THE LAWS OF JAPANESE PAINTING, H. P. Bowie. This classic work on the philosophy and technique of Japanese art is based on the author's first-hand experiences studying art in Japan. Every aspect of Japanese painting is described: the use of the brush and other materials; laws governing conception and execution; subjects for Japanese paintings, etc. The best possible substitute for a series of lessons from a great Oriental master. Index. xv + 117pp. + 66 plates. 6⅛ x 9¼.

20030-2 Paperbound $4.50

A HANDBOOK OF ANATOMY FOR ART STUDENTS, Arthur Thomson. This long-popular text teaches any student, regardless of level of technical competence, all the subtleties of human anatomy. Clear photographs, numerous line sketches and diagrams of bones, joints, etc. Use it as a text for home study, as a supplement to life class work, or as a lifelong sourcebook and reference volume. Author's prefaces. 67 plates, containing 40 line drawings, 86 photographs—mostly full page. 211 figures. Appendix. Index. xx + 459pp. 5⅜ x 8⅜. 21163-0 Paperbound $5.00

WHITTLING AND WOODCARVING, E. J. Tangerman. With this book, a beginner who is moderately handy can whittle or carve scores of useful objects, toys for children, gifts, or simply pass hours creatively and enjoyably. "Easy as well as instructive reading," N. Y. Herald Tribune Books. 464 illustrations, with appendix and index. x + 293pp. 5½ x 8⅛.

20965-2 Paperbound $3.00

ONE HUNDRED AND ONE PATCHWORK PATTERNS, Ruby Short McKim. Whether you have made a hundred quilts or none at all, you will find this the single most useful book on quiltmaking. There are 101 full patterns (all exact size) with full instructions for cutting and sewing. In addition there is some really choice folklore about the origin of the ingenious pattern names: "Monkey Wrench," "Road to California," "Drunkard's Path," "Crossed Canoes," to name a few. Over 500 illustrations. 124 pp. 7⅞ x 10¾. 20773-0 Paperbound $2.50

ART AND GEOMETRY, W. M. Ivins, Jr. Challenges the idea that the foundations of modern thought were laid in ancient Greece. Pitting Greek tactile-muscular intuitions of space against modern visual intuitions, the author, for 30 years curator of prints, Metropolitan Museum of Art, analyzes the differences between ancient and Renaissance painting and sculpture and tells of the first fruitful investigations of perspective. x + 113pp. 5⅜ x 8⅜. 20941-5 Paperbound $2.00

VITRUVIUS: TEN BOOKS ON ARCHITECTURE. The most influential book in the history of architecture. 1st century A.D. Roman classic has influenced such men as Bramante, Palladio, Michelangelo, up to present. Classic principles of design, harmony, etc. Fascinating reading. Definitive English translation by Professor H. Morgan, Harvard. 344pp. 5⅜ x 8.

20645-9 Paperbound $3.75

HAWTHORNE ON PAINTING. Vivid re-creation, from students' notes, of instructions by Charles Hawthorne at Cape Cod School of Art. Essays, epigrammatic comments on color, form, seeing, techniques, etc. "Excellent," Time. 100pp. 5⅜ x 8.

20653-X Paperbound $2.00

THE HANDBOOK OF PLANT AND FLORAL ORNAMENT, R. G. Hatton. 1200 line illustrations, from medieval, Renaissance herbals, of flowering or fruiting plants: garden flowers, wild flowers, medicinal plants, poisons, industrial plants, etc. A unique compilation that probably could not be matched in any library in the world. Formerly "The Craftsman's Plant-Book." Also full text on uses, history as ornament, etc. 548pp. 6⅛ x 9¼.

20649-1 Paperbound $5.95

DECORATIVE ALPHABETS AND INITIALS, Alexander Nesbitt. 91 complete alphabets, over 3900 ornamental initials, from Middle Ages, Renaissance printing, baroque, rococo, and modern sources. Individual items copyright free, for use in commercial art, crafts, design, packaging, etc. 123 full-page plates. 3924 initials. 129pp. 7¾ x 10¾. 20544-4 Paperbound $4.00

METHODS AND MATERIALS OF THE GREAT SCHOOLS AND MASTERS, Sir Charles Eastlake. (Formerly titled "Materials for a History of Oil Painting.") Vast, authentic reconstruction of secret techniques of the masters, recreated from ancient manuscripts, contemporary accounts, analysis of paintings, etc. Oils, fresco, tempera, varnishes, encaustics. Both Flemish and Italian schools, also British and French. One of great works for art historians, critics; inexhaustible mine of suggestions, information for practicing artists. Total of 1025pp. 5⅜ x 8.

20718-8, 20719-6 Two volume set, Paperbound $12.00

AMERICAN VICTORIAN ARCHITECTURE, edited by Arnold Lewis and Keith Morgan. Collection of brilliant photographs of 1870's, 1880's, showing finest domestic, public architecture; many buildings now gone. Landmark work, French in origin; first European appreciation of American work. Modern notes, introduction. 120 plates. "Architects and students of architecture will find this book invaluable for its first-hand depiction of the state of the art during a very formative period," ANTIQUE MONTHLY. 152pp. 9 x 12. 23177-1 Paperbound $6.00

THE HUMAN FIGURE, J. H. Vanderpoel. Not just a picture book, but a complete course by a famous figure artist. Extensive text, illustrated by 430 pencil and charcoal drawings of both male and female anatomy. 2nd enlarged edition. Foreword. 430 illus. 143pp. 6⅛ x 9¼. 20432-4 Paperbound $2.25

GRAPHIC WORLDS OF PETER BRUEGEL THE ELDER,
H. A. Klein. 64 of the finest etchings and engravings made from
the drawings of the Flemish master Peter Bruegel. Every aspect
of the artist's diversified style and subject matter is represented,
with notes providing biographical and other background in-
formation. Excellent reproductions on opaque stock with nothing
on reverse side. 63 engravings, 1 woodcut. Bibliography. xviii +
176pp. 9⅜ x 12¼. 21132-0 Paperbound $6.00

THE COMPLETE WOODCUTS OF ALBRECHT DURER,
edited by Dr. Willi Kurth. Albrecht Dürer was a master in vari-
ous media, but it was in woodcut design that his creative genius
reached its highest expression. Here are all of his extant wood-
cuts, a collection of over 300 great works, many of which are
not available elsewhere. An indispensable work for the art his-
torian and critic and all art lovers. 346 plates. Index. 285pp.
8½ x 12¼. 21097-9 Paperbound $6.00

*CHINESE PAINTING AND CALLIGRAPHY: A PICTORIAL
SURVEY, Wan-go Weng.* Comprehensive survey of Chinese
painting from Northern Sung (960–1127) to early Ch'ing dynasty
(1644–1911). 149 reproductions from Crawford Collection, finest
private holding in the West. Emphasis on pivotal painters, callig-
raphers—landscapes from Ming, Sung eras, three classic styles
of calligraphy shown. 109 illustrations, including many two-page
spreads. Finest reproductions of any Dover book. 192pp. 8⅞
x 11¾. 23707-9 Paperbound $7.95

WILD FOWL DECOYS, Joel Barber. Antique dealers, collectors,
craftsmen, hunters, readers of Americana, etc. will find this the
only thorough and reliable guide on the market today to this
unique folk art. It contains the history, cultural significance, re-
gional design variations; unusual decoy lore; working plans for
constructing decoys; and loads of illustrations. 140 full-page
plates, 4 in color. 14 additional plates of drawings and plans by
the author. xxvii + 156pp. 7⅞ x 10¾. 20011-6 Paperbound $5.00

1800 WOODCUTS BY THOMAS BEWICK AND HIS SCHOOL.
This is the largest collection of first-rate pictorial woodcuts in
print—an indispensable part of the working library of every
commercial artist, art director, production designer, packaging
artist, craftsman, manufacturer, librarian, art collector, and
artist. And best of all, when you buy your copy of Bewick, you
buy the rights to reproduce individual illustrations—no permis-
sion needed, no acknowledgments, no clearance fees! Classified
index. Bibliography and sources. xiv + 246pp. 9 x 12.
20766-8 Paperbound $6.00

THE SCRIPT LETTER, Tommy Thompson. Prepared by a noted
authority, this is a thorough, straightforward course of instruc-
tion with advice on virtually every facet of the art of script
lettering. Also a brief history of lettering with examples from
early copy books and illustrations from present day advertising
and packaging. Copiously illustrated. Bibliography. 128pp.
6½ x 9⅛. 21311-0 Paperbound $2.50

PINE FURNITURE OF EARLY NEW ENGLAND, R. H. Kettell. Over 400 illustrations, over 50 working drawings of early New England chairs, benches, beds, cupboards, mirrors, shelves, tables, other furniture esteemed for simple beauty and character. "Rich store of illustrations . . . emphasizes the individuality and varied design," ANTIQUES. 413 illustrations, 55 working drawings. 475pp. 8 x 10¾. 20145-7 Clothbound $12.95

BASIC BOOKBINDING, A. W. Lewis. Enables both beginners and experts to rebind old books or bind paperbacks in hard covers. Treats materials, tools; gives step-by-step instruction in how to collate a book, sew it, back it, make boards, etc. 261 illus. Appendices. 155pp. 5⅜ x 8. 20169-4 Paperbound $2.00

DESIGN MOTIFS OF ANCIENT MEXICO, J. Enciso. Nearly 90% of these 766 superb designs from Aztec, Olmec, Totonac, Maya, and Toltec origins are unobtainable elsewhere. Contains plumed serpents, wind gods, animals, demons, dancers, monsters, etc. Excellent applied design source. Originally $17.50. 766 illustrations, thousands of motifs. 192pp. 6⅛ x 9¼. 20084-1 Paperbound $2.50

A DIDEROT PICTORIAL ENCYCLOPEDIA OF TRADES AND INDUSTRY. Manufacturing and the Technical Arts in Plates Selected from "L'Encyclopédie ou Dictionnaire Raisonné des Sciences, des Arts, et des Métiers," of Denis Diderot, edited with text by C. Gillispie. Over 2000 illustrations on 485 full-page plates. Magnificent 18th-century engravings of men, women, and children working at such trades as milling flour, cheesemaking, charcoal burning, mining, silverplating, shoeing horses, making fine glass, printing, hundreds more, showing details of machinery, different steps in sequence, etc. A remarkable art work, but also the largest collection of working figures in print, copyright-free, for art directors, designers, etc. Two vols. 920pp. 9 x 12. Heavy library cloth. 22284-5. 22283-3 Two volume set $40.00

SILK SCREEN TECHNIQUES, J. Biegeleisen, M. Cohn. A practical step-by-step home course in one of the most versatile, least expensive graphic arts processes. How to build an inexpensive silk screen, prepare stencils, print, achieve special textures, use color, etc. Every step explained, diagrammed. 149 illustrations, 201pp. 6⅛ x 9¼. 20433-2 Paperbound $2.75

STICKS AND STONES, Lewis Mumford. An examination of forces influencing American architecture: the medieval tradition in early New England, the classical influence in Jefferson's time, the Brown Decades, the imperial facade, the machine age, etc. "A truly remarkable book," SAT. REV. OF LITERATURE. 2nd revised edition. 21 illus. xvii + 240pp. 5⅜ x 8. 20202-X Paperbound $2.50

THE AUTOBIOGRAPHY OF AN IDEA, Louis Sullivan. The architect whom Frank Lloyd Wright called "the master," records the development of the theories that revolutionized America's skyline. 34 full-page plates of Sullivan's finest work. New introduction by R. M. Line. xiv + 335pp. 5⅜ x 8. 20281-X Paperbound $4.00

AN ATLAS OF ANIMAL ANATOMY FOR ARTISTS, W. Ellenberger, H. Baum, H. Dittrich. The largest, richest animal anatomy for artists in English. Form, musculature, tendons, bone structure, expression, detailed cross sections of head, other features, of the horse, lion, dog, cat, deer, seal, kangaroo, cow, bull, goat, monkey, hare, many other animals. "Highly recommended," DESIGN. Second, revised, enlarged edition with new plates from Cuvier, Stubbs, etc. 288 illustrations. 153pp. 11⅜ x 9.

20082-5 Paperbound $4.50

ANIMAL DRAWING: ANATOMY AND ACTION FOR ARTISTS, C. R. Knight. 158 studies, with full accompanying text, of such animals as the gorilla, bear, bison, dromedary, camel, vulture, pelican, iguana, shark, etc., by one of the greatest modern masters of animal drawing. Innumerable tips on how to get life expression into your work. "An excellent reference work," SAN FRANCISCO CHRONICLE. 158 illustrations. 156pp. 10½ x 8½.

20426-X Paperbound $4.00

ARCHITECTURAL AND PERSPECTIVE DESIGNS, Giuseppe Galli Bibiena. 50 imaginative scenic drawings of Giuseppe Galli Bibiena, principal theatrical engineer and architect to the Viennese court of Charles VI. Aside from its interest to art historians, students, and art lovers, there is a whole Baroque world of material in this book for the commercial artist. Portrait of Charles VI by Martin de Meytens. 1 allegorical plate. 50 additional plates. New introduction. vi + 103pp. 10⅛ x 13¼.

21263-7 Paperbound $5.00

HANDBOOK OF DESIGNS AND DEVICES, C. P. Hornung. A remarkable working collection of 1836 basic designs and variations, all copyright-free. Variations of circle, line, cross, diamond, swastika, star, scroll, shield, many more. Notes on symbolism. "A necessity to every designer who would be original without having to labor heavily," ARTIST AND ADVERTISER. 204 plates. 240pp. 5⅜ x 8.

20125-2 Paperbound $2.75

CHINESE HOUSEHOLD FURNITURE, G. N. Kates. A summary of virtually everything that is known about authentic Chinese furniture before it was contaminated by the influence of the West. The text covers history of styles, materials used, principles of design and craftsmanship, and furniture arrangement—all fully illustrated. xiii + 190pp. 5⅝ x 8½.

20958-X Paperbound $3.00

DECORATIVE ART OF THE SOUTHWESTERN INDIANS, D. S. Sides. 300 black and white reproductions from one of the most beautiful art traditions of the primitive world, ranging from the geometric art of the Great Pueblo period of the 13th century to modern folk art. Motives from basketry, beadwork, Zuni masks, Hopi kachina dolls, Navajo sand pictures and blankets, and ceramic ware. Unusual and imaginative designs will inspire craftsmen in all media, and commercial artists may reproduce any of them without permission or payment. xviii + 101pp. 5⅝ x 8⅜.

20139-2 Paperbound $1.95

ANIMALS IN MOTION, Eadweard Muybridge. The largest collection of animal action photos in print. 34 different animals (horses, mules, oxen, goats, camels, pigs, cats, lions, gnus, deer, monkeys, eagles—and 22 others) in 132 characteristic actions. All 3919 photographs are taken in series at speeds up to 1/1600th of a second, offering artists, biologists, cartoonists a remarkable opportunity to see exactly how an ostrich's head bobs when running, how a lion puts his foot down, how an elephant's knee bends, how a bird flaps his wings, thousands of other hard-to-catch details. "A really marvellous series of plates," NATURE. 380 full-page plates. Heavy glossy stock, reinforced binding with headbands. 7⅞ x 10¾. 20203-8 Clothbound $15.00

THE BOOK OF SIGNS, R. Koch. 493 symbols—crosses, monograms, astrological, biological symbols, runes, etc.—from ancient manuscripts, cathedrals, coins, catacombs, pottery. May be reproduced permission-free. 493 illustrations by Fritz Kredel. 104pp. 6⅛ x 9¼. 20162-7 Paperbound $2.00

A HANDBOOK OF EARLY ADVERTISING ART, C. P. Hornung. The largest collection of copyright-free early advertising art ever compiled. Vol. I: 2,000 illustrations of animals, old automobiles, buildings, allegorical figures, fire engines, Indians, ships, trains, more than 33 other categories! Vol. II: Over 4,000 typographical specimens; 600 Roman, Gothic, Barnum, Old English faces; 630 ornamental type faces; hundreds of scrolls, initials, flourishes, etc. "A remarkable collection," PRINTERS' INK.

Vol. I: Pictorial Volume. Over 2000 illustrations. 256pp. 9 x 12.
 20122-8 Clothbound $12.95

Vol. II: Typographical Volume. Over 4000 specimens. 319pp. 9 x 12. 20123-6 Clothbound $13.50

Two volume set, Clothbound, only $26.45

THE UNIVERSAL PENMAN, George Bickham. Exact reproduction of beautiful 18th-century book of handwriting. 22 complete alphabets in finest English roundhand, other scripts, over 2000 elaborate flourishes, 122 calligraphic illustrations, etc. Material is copyright-free. "An essential part of any art library, and a book of permanent value," AMERICAN ARTIST. 212 plates. 224pp. 9 x 13¾. 20616-5 Paperbound $6.95

AN ATLAS OF ANATOMY FOR ARTISTS, F. Schider. This standard work contains 189 full-page plates, more than 647 illustrations of all aspects of the human skeleton, musculature, cutaway portions of the body, each part of the anatomy, hand forms, eyelids, breasts, location of muscles under the flesh, etc. 59 plates illustrate how Michelangelo, da Vinci, Goya, 15 others, drew human anatomy. New 3rd edition enlarged by 52 new illustrations by Cloquet, Barcsay. "The standard reference tool," AMERICAN LIBRARY ASSOCIATION. "Excellent," AMERICAN ARTIST. 189 plates, 647 illustrations. xxvi + 192pp. 7⅞ x 10⅝. 20241-0 Clothbound $6.95

GREEK REVIVAL ARCHITECTURE IN AMERICA, T. Hamlin. A comprehensive study of the American Classical Revival, its regional variations, reasons for its success and eventual decline. Profusely illustrated, displaying the work of almost every important architect. 2 appendices. 59 figures, 94 plates containing 221 photos, 62 architectural designs, drawings, etc. 324-item classified bibliography. Index. xi + 439pp. 5⅜ x 8½.

21148-7 Paperbound $5.00

CREATIVE LITHOGRAPHY AND HOW TO DO IT, Grant Arnold. Written by a man who practiced and taught lithography for many years, this highly useful volume explains all the steps of the lithographic process from tracing the drawings on the stone to printing the lithograph, with helpful hints for solving special problems. Index. 16 reproductions of lithographs. 11 drawings. xv + 214pp. of text. 5⅜ x 8½.

21208-4 Paperbound $3.50

ARABIC ART IN COLOR, Prisse d'Avennes. 50 full-color plates from rare 19th-century volumes by noted French historian. 141 authentic Islamic designs and motifs from Cairo art treasures include florals, geometrics, Koran illuminations, spots, borders, etc. Ranging from 12th to 18th century, these exquisite illustrations will interest artists, designers of textiles and wallpaper, craftspeople working in stained glass, rugs, etc. Captions. 46pp. 9⅜ x 12¼.

23658-7 Paperbound $6.00

PAINTING IN THE FAR EAST, L. Binyon. A study of over 1500 years of Oriental art by one of the world's outstanding authorities. The author chooses the most important masters in each period—Wu Tao-tzu, Toba Sojo, Kanaoka, Li Lung-mien, Masanobu, Okio, etc.—and examines the works, schools, and influence of each within their cultural context. 42 photographs. Sources of original works and selected bibliography. Notes including list of principal painters by periods. xx + 297pp. 6⅛ x 9¼.

20520-7 Paperbound $5.00

THE ALPHABET AND ELEMENTS OF LETTERING, F. W. Goudy. A beautifully illustrated volume on the aesthetics of letters and type faces and their history and development. Each plate consists of 15 forms of a single letter with the last plate devoted to the ampersand and the numerals. 27 full-page plates. 48 additional figures. xii + 131pp. 7⅞ x 10¾.

20792-7 Paperbound $3.50

THE COMPLETE BOOK OF SILK SCREEN PRINTING PRODUCTION, J. I. Biegeleisen. Here is a clear and complete picture of every aspect of silk screen technique and press operation—from individually operated manual presses to modern automatic ones. Unsurpassed as a guidebook for setting up shop, making shop operation more efficient, finding out about latest methods and equipment; or as a textbook for use in teaching, studying, or learning all aspects of the profession. 124 figures. Index. Bibliography. List of Supply Sources. xi + 253pp. 5⅜ x 8½.

21100-2 Paperbound $2.75

MASTERPIECES OF FURNITURE, Verna Cook Salomonsky.
Photographs and measured drawings of some of the finest ex-
amples of Colonial American, 17th century English, Windsor,
Sheraton, Hepplewhite, Chippendale, Louis XIV, Queen Anne,
and various other furniture styles. The textual matter includes
information on traditions, characteristics, background, etc. of
various pieces. 101 plates. Bibliography. 224pp. 7⅞ x 10¾.

21381-1 Paperbound $4.50

PRIMITIVE ART, Franz Boas. In this exhaustive volume, a
great American anthropologist analyzes all the fundamental
traits of primitive art, covering the formal element in art, repre-
sentative art, symbolism, style, literature, music, and the dance.
Illustrations of Indian embroidery, paleolithic paintings, woven
blankets, wing and tail designs, totem poles, cutlery, earthen-
ware, baskets and many other primitive objects and motifs. Over
900 illustrations. 376pp. 5⅜ x 8. 20025-6 Paperbound $3.95

*AN INTRODUCTION TO A HISTORY OF WOODCUT, A. M.
Hind.* Nearly all of this authoritative 2-volume set is devoted to
the 15th century—the period during which the woodcut came of
age as an important art form. It is the most complete compendium
of information on this period, the artists who contributed to it,
and their technical and artistic accomplishments. Profusely il-
lustrated with cuts by 15th century masters, and later works
for comparative purposes. 484 illustrations. 5 indexes. Total of
xi+838pp. 5⅜ x 8½.Two-vols. 20952-0,20953-0 Paperbound $12.00

A HISTORY OF ENGRAVING AND ETCHING, A. M. Hind.
Beginning with the anonymous masters of 15th century en-
graving, this highly regarded and thorough survey carries you
through Italy, Holland, and Germany to the great engravers and
beginnings of etching in the 16th century, through the portrait
engravers, master etchers, practicioners of mezzotint, crayon
manner and stipple, aquatint, color prints, to modern etching
in the period just prior to World War I. Beautifully illustrated
—sharp clear prints on heavy opaque paper. Author's preface.
3 appendixes. 111 illustrations. xviii + 487 pp. 5⅜ x 8½.

20954-7 Paperbound $6.00

ART STUDENTS' ANATOMY, E. J. Farris. Teaching anatomy
by using chiefly living objects for illustration, this study has
enjoyed long popularity and success in art courses and home-
study programs. All the basic elements of the human anatomy
are illustrated in minute detail, diagrammed and pictured as they
pass through common movements and actions. 158 drawings,
photographs, and roentgenograms. Glossary of anatomical terms.
x + 159pp. 5⅝ x 8⅜. 20744-7 Paperbound $2.75

COLONIAL LIGHTING, A. H. Hayward. The only book to cover
the fascinating story of lamps and other lighting devices in
America. Beginning with rush light holders used by the early
settlers, it ranges through the elaborate chandeliers of the Fed-
eral period, illustrating 647 lamps. Of great value to antique
collectors, designers, and historians of arts and crafts. Revised
and enlarged by James R. Marsh. xxxi + 198pp. 5⅝ x 8¼.

20975-X Paperbound $3.50

ART ANATOMY, Dr. William Rimmer. One of the few books on art anatomy that are themselves works of art, this is a faithful reproduction (rearranged for handy use) of the extremely rare masterpiece of the famous 19th century anatomist, sculptor, and art teacher. Beautiful, clear line drawings show every part of the body—bony structure, muscles, features, etc. Unusual are the sections on falling bodies, foreshortenings, muscles in tension, grotesque personalities, and Rimmer's remarkable interpretation of emotions and personalities as expressed by facial features. It will supplement every other book on art anatomy you are likely to have. Reproduced clearer than the lithographic original (which sells for $500 on up on the rare book market.) Over 1,200 illustrations. xiii + 153pp. 7¾ x 10¾.

20908-3 Paperbound $4.00

THE CRAFTSMAN'S HANDBOOK, Cennino Cennini. The finest English translation of IL LIBRO DELL' ARTE, the 15th century introduction to art technique that is both a mirror of Quatrocento life and a source of many useful but nearly forgotten facets of the painter's art. 4 illustrations. xxvii + 142pp. D. V. Thompson, translator. 5⅜ x 8. 20054-X Paperbound $2.50

THE BROWN DECADES, Lewis Mumford. A picture of the "buried renaissance" of the post-Civil War period, and the founding of modern architecture (Sullivan, Richardson, Root, Roebling), landscape development (Marsh, Olmstead, Eliot), and the graphic arts (Homer, Eakins, Ryder). 2nd revised, enlarged edition. Bibliography. 12 illustrations. xiv + 266 pp. 5⅜ x 8.

20200-3 Paperbound $2.50

THE STYLES OF ORNAMENT, A. Speltz. The largest collection of line ornament in print, with 3750 numbered illustrations arranged chronologically from Egypt, Assyria, Greeks, Romans, Etruscans, through Medieval, Renaissance, 18th century, and Victorian. No permissions, no fees needed to use or reproduce illustrations. 400 plates with 3750 illustrations. Bibliography. Index. 640pp. 6 x 9. 20577-6 Paperbound $6.00

THE ART OF ETCHING, E. S. Lumsden. Every step of the etching process from essential materials to completed proof is carefully and clearly explained, with 24 annotated plates exemplifying every technique and approach discussed. The book also features a rich survey of the art, with 105 annotated plates by masters. Invaluable for beginner to advanced etcher. 374pp. 5⅜ x 8. 20049-3 Paperbound $3.75

OF THE JUST SHAPING OF LETTERS, Albrecht Dürer. This remarkable volume reveals Albrecht Dürer's rules for the geometric construction of Roman capitals and the formation of Gothic lower case and capital letters, complete with construction diagrams and directions. Of considerable practical interest to the contemporary illustrator, artist, and designer. Translated from the Latin text of the edition of 1535 by R. T. Nichol. Numerous letterform designs, construction diagrams, illustrations. iv + 43pp. 7⅞ x 10¾. 21306-4 Paperbound $2.50

AFRICAN SCULPTURE, Ladislas Segy. 163 full-page plates illustrating masks, fertility figures, ceremonial objects, etc., of 50 West and Central African tribes—95% never before illustrated. 34-page introduction to African sculpture. "Mr. Segy is one of its top authorities," NEW YORKER. 164 full-page photographic plates. Introduction. Bibliography. 244pp. 6⅛ x 9¼.

20396-4 Paperbound $3.00

CALLIGRAPHY, J. G. Schwandner. First reprinting in 200 years of this legendary book of beautiful handwriting. Over 300 ornamental initials, 12 complete calligraphic alphabets, over 150 ornate frames and panels, 75 calligraphic pictures of cherubs, stags, lions, etc., thousands of flourishes, scrolls, etc., by the greatest 18th-century masters. All material can be copied or adapted without permission. Historical introduction. 158 full-page plates. 368pp. 9 x 13. 20475-8 Paperbound $6.00

DRAWINGS OF MUCHA, Alphonse Maria Mucha. 70 large-sized illustrations (including 9 in full color) survey the surprisingly cohesive expanse of Mucha's draftsmanship. Original plans, ideas, etc., for such works as "The Seasons," famous poster for the St. Louis World's Fair, drawings of Sarah Bernhardt, etc. Adds new power to the resurgence of critical acclaim for Mucha's art. 75pp. 9⅜ x 12¼. 23672-2 Paperbound $4.00

FRENCH OPERA POSTERS 1868–1930, Lucy Broido. 53 posters (32 in full color) cover gaiety and epic passions of French opera of La Belle Epoque. Chéret, Steinlen, Grasset and 30 other artists create posters for Massenet, Offenbach, Delibes, Fauré, Février and others. Introduction, extensive notes by Lucy Broido. 96pp. 9⅜ x 12¼. 23306-5 Paperbound $5.00

DESIGN FOR ARTISTS AND CRAFTSMEN, Louis Wolchonok. Recommended for either individual or classroom use, this book helps you to create original designs from things about you, from geometric patterns, from plants, animals, birds, humans, landscapes, manmade objects. "A great contribution," N. Y. Society of Craftsmen. 113 exercises with hints and diagrams. More than 1280 illustrations. xv + 207pp. 7⅞ x 10¾.

20274-7 Paperbound $4.00

HANDBOOK OF ORNAMENT, F. S. Meyer. One of the largest collections of copyright-free traditional art: over 3300 line cuts of Greek, Roman, Medieval, Renaissance, Baroque, 18th and 19th century art motifs (tracery, geometric elements, flower and animal motifs, etc.) and decorated objects (chairs, thrones, weapons, vases, jewelry, armor, etc.). Full text. 300 plates. 3300 illustrations. 562pp. 5⅜ x 8. 20302-6 Paperbound $5.00

THREE CLASSICS OF ITALIAN CALLIGRAPHY, Oscar Ogg, ed. Exact reproductions of three famous Renaissance calligraphic works: Arrighi's OPERINA and IL MODO, Tagliente's LO PRESENTE LIBRO, and Palatino's LIBRO NUOVO. More than 200 complete alphabets, thousands of lettered specimens, in Papal Chancery and other beautiful, ornate handwriting. Introduction. 245 plates. 282pp. 6⅛ x 9¼. 20212-7 Paperbound $4.00

PRINCIPLES OF ART HISTORY, H. Wölfflin. This remarkably instructive work demonstrates the tremendous change in artistic conception from the 14th to the 18th centuries, by analyzing 164 works by Botticelli, Dürer, Hobbema, Holbein, Hals, Titian, Rembrandt, Vermeer, etc., and pointing out exactly what is meant by "baroque," "classic," "primitive," "picturesque," and other basic terms of art history and criticism. "A remarkable lesson in the art of seeing," SAT. REV. OF LITERATURE. Translated from the 7th German edition. 150 illus. 254pp. 6⅛ x 9¼. 20276-3 Paperbound $3.50

FOUNDATIONS OF MODERN ART, A. Ozenfant. Stimulating discussion of human creativity from paleolithic cave painting to modern painting, architecture, decorative arts. Fully illustrated with works of Gris, Lipchitz, Léger, Picasso, primitive, modern artifacts, architecture, industrial art, much more. 226 illustrations. 368pp. 6⅛ x 9¼. 20215-1 Paperbound $5.00

METALWORK AND ENAMELLING, H. Maryon. Probably the best book ever written on the subject. Tells everything necessary for the home manufacture of jewelry, rings, ear pendants, bowls, etc. Covers materials, tools, soldering, filigree, setting stones, raising patterns, repoussé work, damascening, niello, cloisonné, polishing, assaying, casting, and dozens of other techniques. The best substitute for apprenticeship to a master metalworker. 363 photos and figures. 374pp. 5½ x 8½.

 22702-2 Paperbound $4.00

SHAKER FURNITURE, E. D. and F. Andrews. The most illuminating study of Shaker furniture ever written. Covers chronology, craftsmanship, houses, shops, etc. Includes over 200 photographs of chairs, tables, clocks, beds, benches, etc. "Mr. & Mrs. Andrews know all there is to know about Shaker furniture," Mark Van Doren, NATION. 48 full-page plates. 192pp. 7⅞ x 10¾. 20679-3 Paperbound $4.00

LETTERING AND ALPHABETS, J. A. Cavanagh. An unabridged reissue of "Lettering," containing the full discussion, analysis, illustration of 89 basic hand lettering styles based on Caslon, Bodoni, Gothic, many other types. Hundreds of technical hints on construction, strokes, pens, brushes, etc. 89 alphabets, 72 lettered specimens, which may be reproduced permission-free. 121pp. 9¾ x 8. 20053-1 Paperbound $2.50

THE HUMAN FIGURE IN MOTION, Eadweard Muybridge. The largest collection in print of Muybridge's famous high-speed action photos. 4789 photographs in more than 500 action-strip-sequences (at shutter speeds up to 1/6000th of a second) illustrate men, women, children—mostly undraped—performing such actions as walking, running, getting up, lying down, carrying objects, throwing, etc. "An unparalleled dictionary of action for all artists," AMERICAN ARTIST. 390 full-page plates, with 4789 photographs. Heavy glossy stock, reinforced binding with headbands. 7⅞ x 10¾. 20204-6 Clothbound $13.50

PENNSYLVANIA DUTCH AMERICAN FOLK ART, H. J. Kauffman. The originality and charm of this early folk art give it a special appeal even today, and surviving pieces are sought by collectors all over the country. Here is a rewarding introductory guide to the Dutch country and its household art, concentrating on pictorial matter—hex signs, tulip ware, weather vanes, interiors, paintings and folk sculpture, rocking horses and children's toys, utensils, Stiegel-type glassware, etc. "A serious, worthy and helpful volume," W. G. Dooley, N. Y. TIMES. Introduction. Bibliography. 279 halftone illustrations. 28 motifs and other line drawings. 1 map. 146pp. 7⅞ x 10¾.
21205-X Paperbound $4.00

DESIGN AND EXPRESSION IN THE VISUAL ARTS, J. F. A. Taylor. Here is a much needed discussion of art theory which relates the new and sometimes bewildering directions of 20th century art to the great traditions of the past. The first discussion of principle that addresses itself to the eye rather than to the intellect, using illustrations from Rembrandt, Leonardo, Mondrian, El Greco, etc. List of plates. Index. 59 reproductions. 5 color plates. 75 figures. x + 245pp. 5⅜ x 8½.
21195-9 Paperbound $3.50

THE ENJOYMENT AND USE OF COLOR, W. Sargent. Requiring no special technical know-how, this book tells you all about color and how it is created, perceived, and imitated in art. Covers many little-known facts about color values, intensities, effects of high and low illumination, complementary colors, and color harmonies. Simple do-it-yourself experiments and observations. 35 illustrations, including 6 full-page color plates. New color frontispiece. Index. x + 274 pp. 5⅜ x 8.
20944-X Paperbound $3.50

STYLES IN PAINTING, Paul Zucker. By comparing paintings of similar subject matter, the author shows the characteristics of various painting styles. You are shown at a glance the differences between reclining nudes by Giorgione, Velasquez, Goya, Modigliani; how a Byzantine portrait is unlike a portrait by Van Eyck, da Vinci, Dürer, or Marc Chagall; how the painting of landscapes has changed gradually from ancient Pompeii to Lyonel Feininger in our own century. 241 beautiful, sharp photographs illustrate the text. xiv + 338 pp. 5⅝ x 8¼.
20760-9 Paperbound $4.00

Dover publishes books on commercial art, art history, crafts, design, art classics; also books on music, literature, science, mathematics, puzzles and entertainments, chess, engineering, biology, philosophy, psychology, languages, history, and other fields. For free circulars write to Dept. DA, Dover Publications, Inc., 180 Varick St., New York, N.Y. 10014.